FLORAL PATTERNS

120 Full-Color Designs in the Art Nouveau Style

by

M.P. VERNEUIL

Selected and Arranged by
Carol Belanger Grafton

Dover Publications, Inc.
New York

Publisher's Note

Artists as well as teachers in the Art Nouveau period saw clearly just how crucial and central flower and plant forms were to their universe of design. In his monumental *Etude de la Plante*, published about 1900, one of the finest of these artists and most influential of these teachers, M. P. Verneuil, studied dozens of plant species and for each one gave examples — in the form of magnificent color illustrations — of its design applications in a multitude of commercial arts: textiles, ceramics, stained glass, wallpaper, stencils and the like. Cultivated and wild flowers, blossoming trees and shrubs, reeds and rushes, mushrooms — even seaweed — all suggested wonderful patterns, many in the useful form of borders, roundels, corners and vignettes as well as large-scale and allover patterns. The present selection, with the full color faithfully reproduced, includes a great variety of these patterns and designs, some of them depicted on actual ceramic and other objects, together with a few of Verneuil's perceptive studies of the natural plants. In other words, what is offered here is the best and most useful material from one of the fundamental authentic style books of the Art Nouveau era.

TITLE PAGE: 1. Wisteria. THIS PAGE: 2. Wood anemone.

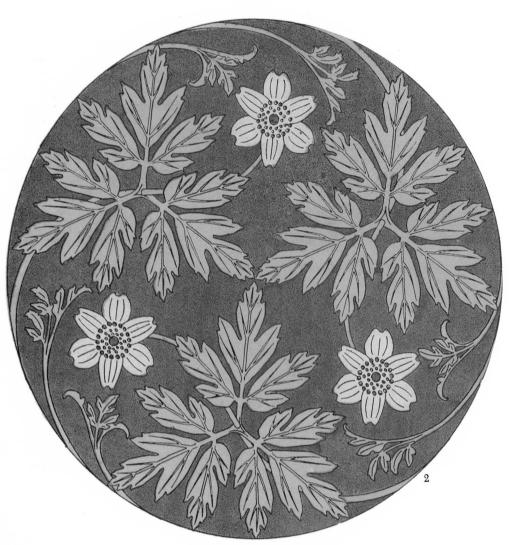

2

Published in Canada by General Publishing Company, Ltd., 30 Lesmill Road, Don Mills, Toronto, Ontario.

Published in the United Kingdom by Constable and Company, Ltd., 10 Orange Street, London WC2H 7EG.

This Dover edition, first published in 1981, is a new selection of illustrations from the work *Etude de la Plante: son application aux industries d'art*, published by the Librairie Centrale des Beaux-Arts, Paris, n.d. (ca. 1900). The Publisher's Note and English captions are new features of the present edition.

DOVER *Pictorial Archive* SERIES

International Standard Book Number: 0-486-24112-2
Library of Congress Catalog Card Number: 80-71099

Manufactured in the United States of America
Dover Publications, Inc.
180 Varick Street
New York, N.Y. 10014

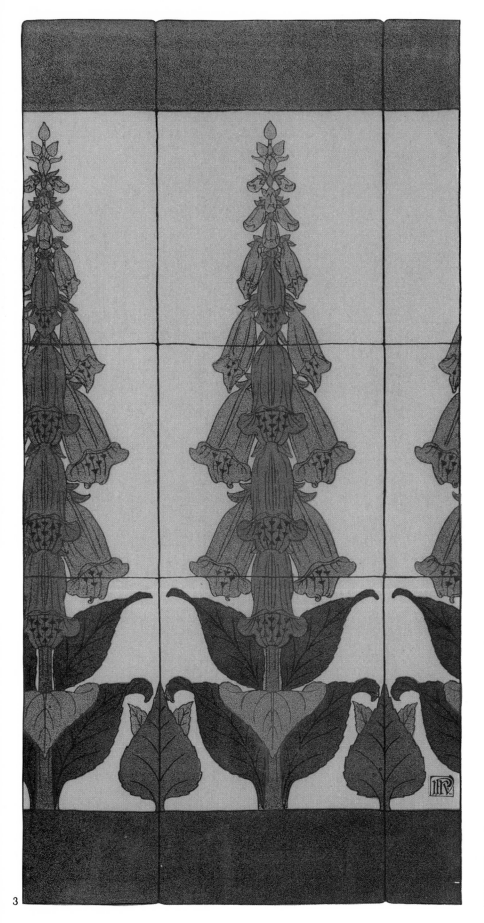

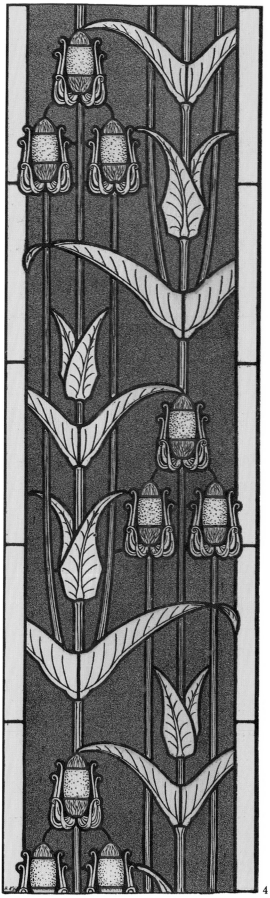

3

4

3. Foxglove. 4. Teasel.

3

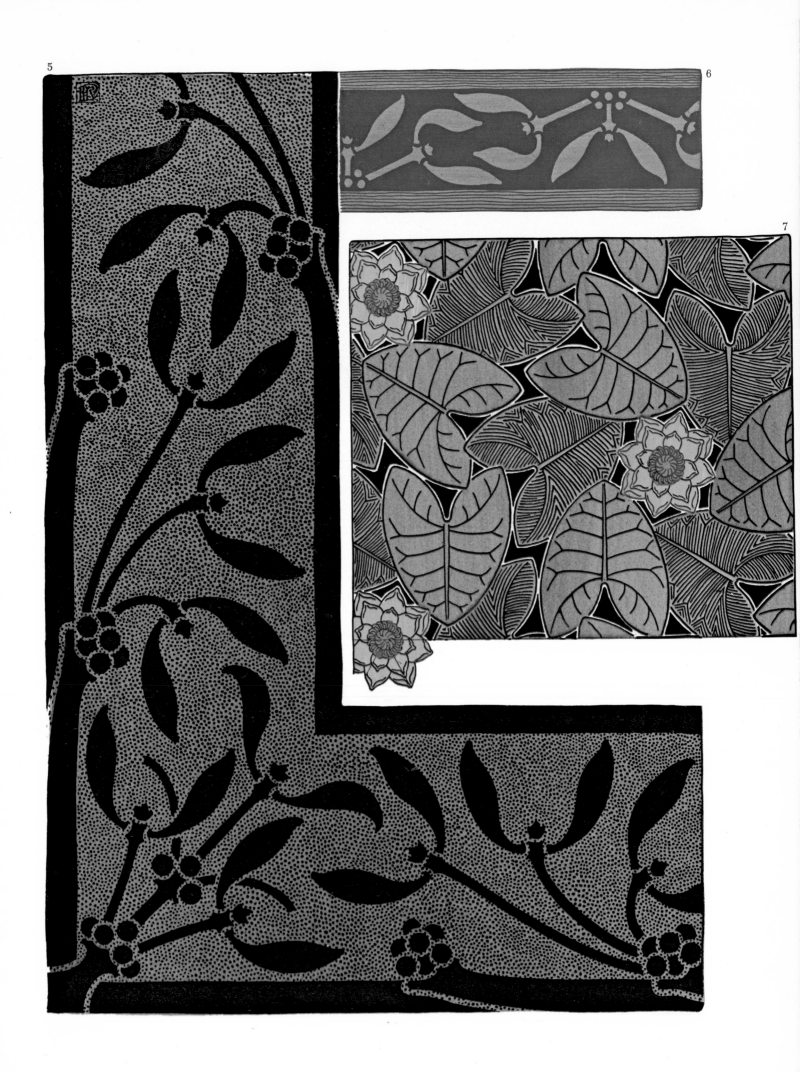

5 & 6. Mistletoe. 7. Water lily. 8. Periwinkle. 9. Species of iris. 10. Columbine. 11. Water lily.

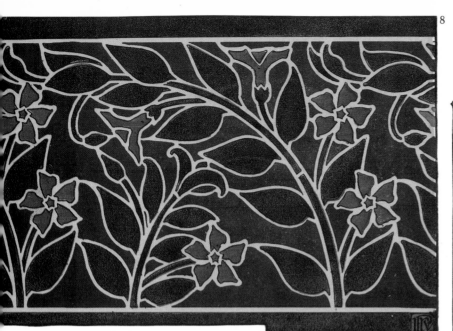

8

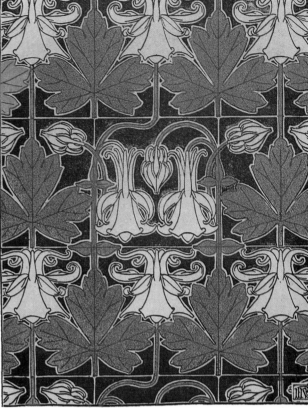

10

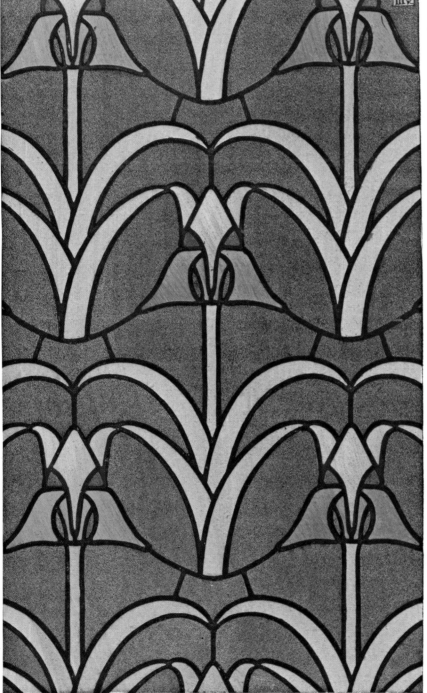

9

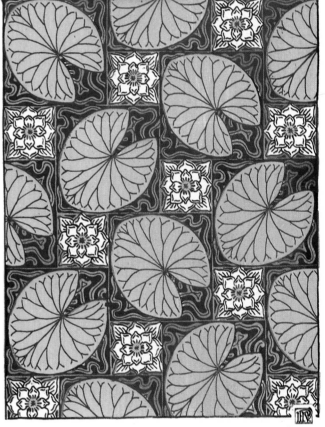

11

12

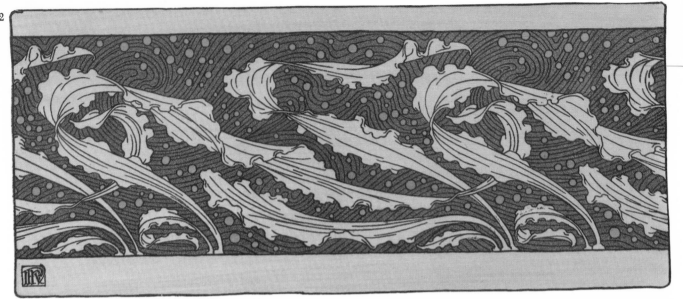

13

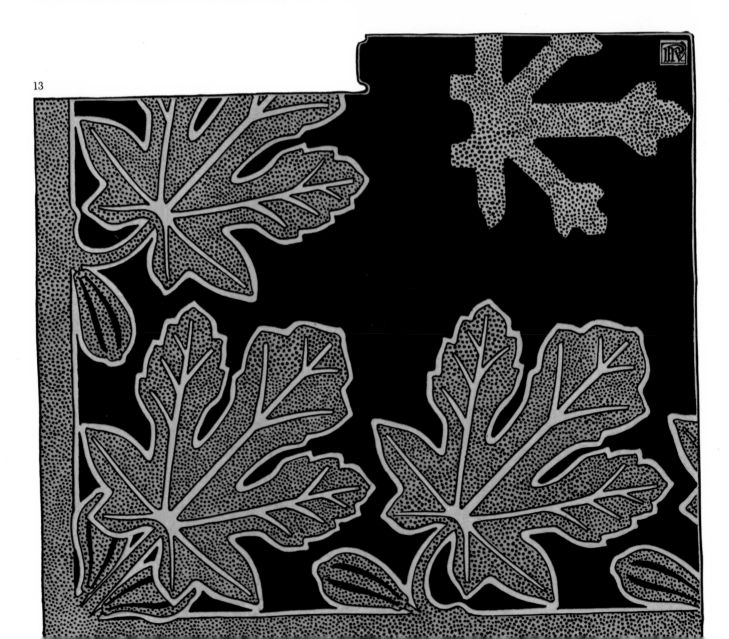

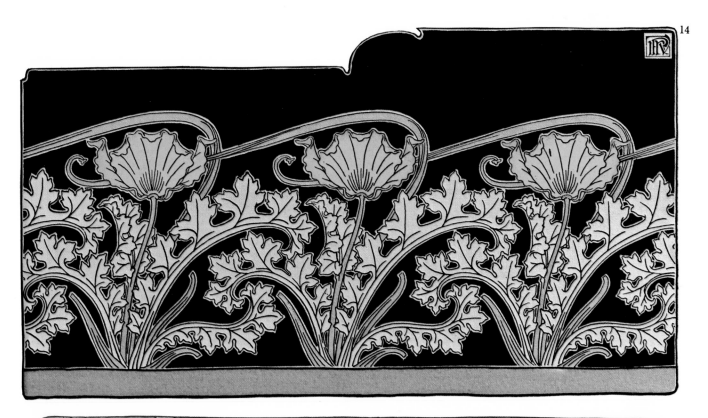

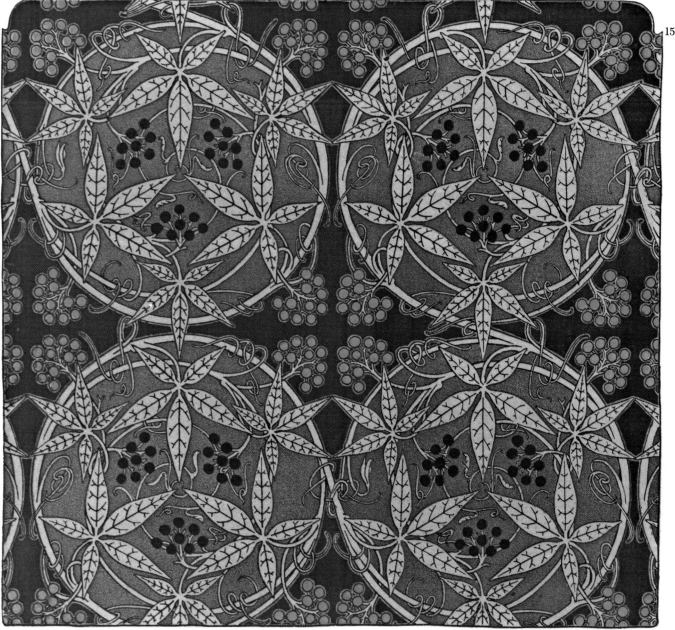

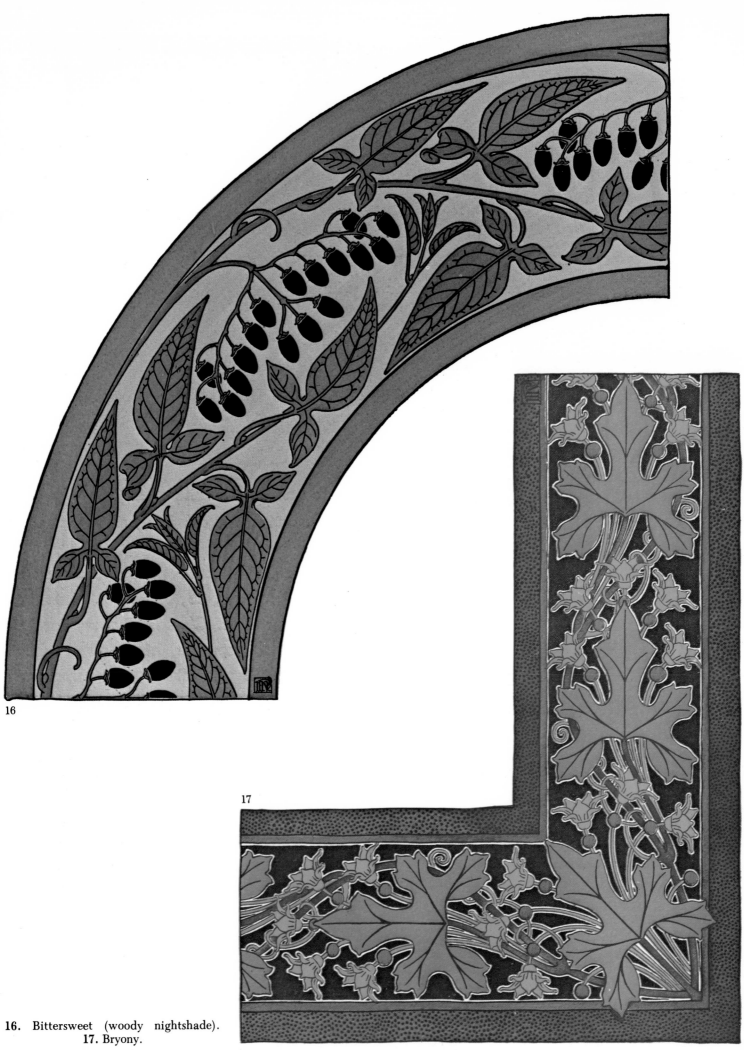

16. Bittersweet (woody nightshade).
17. Bryony.

8

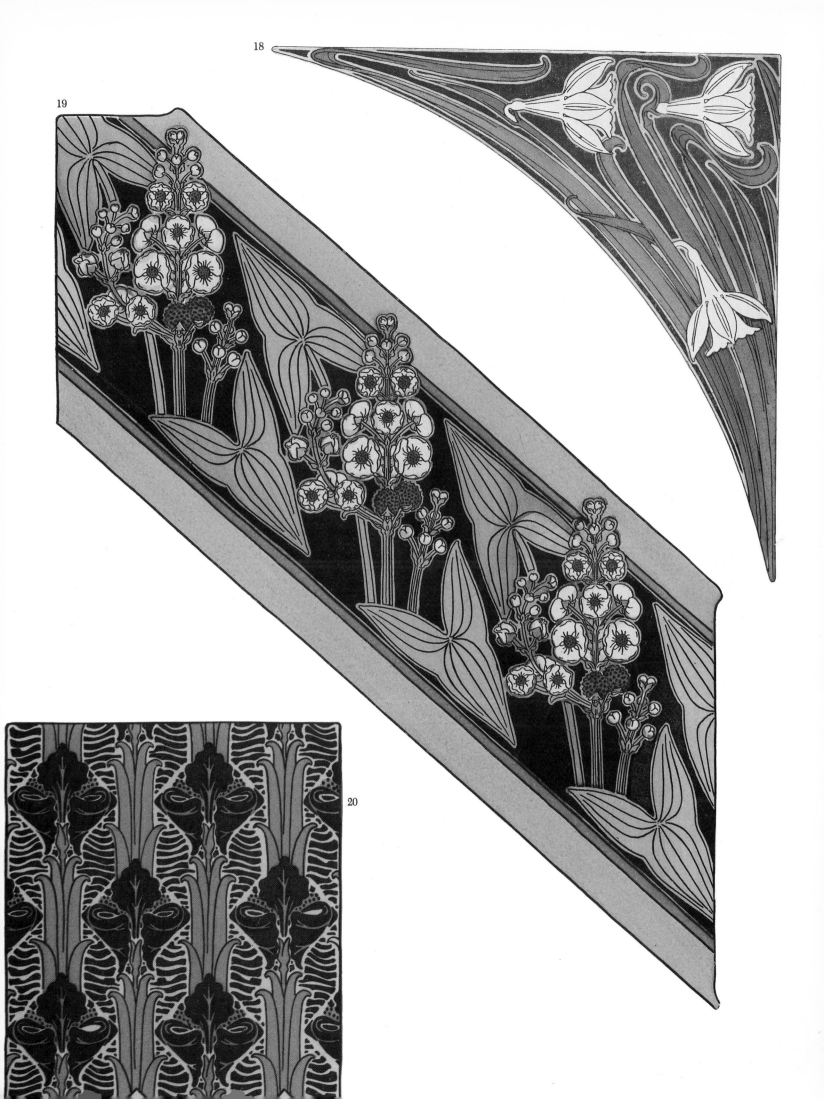

18

19

20

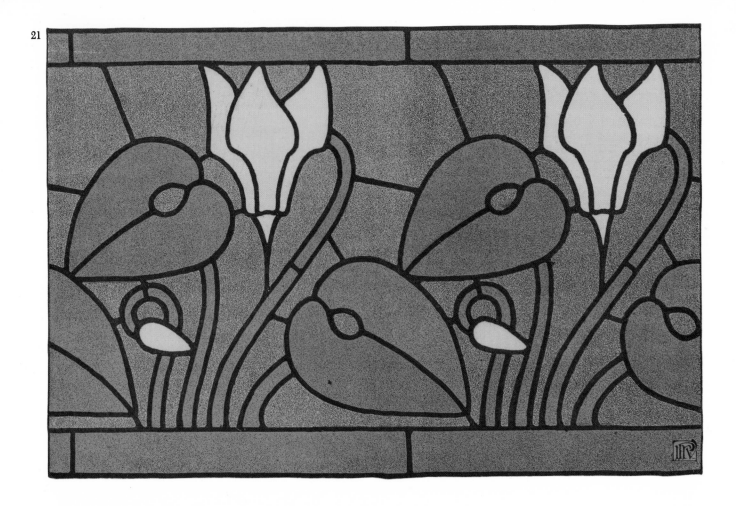

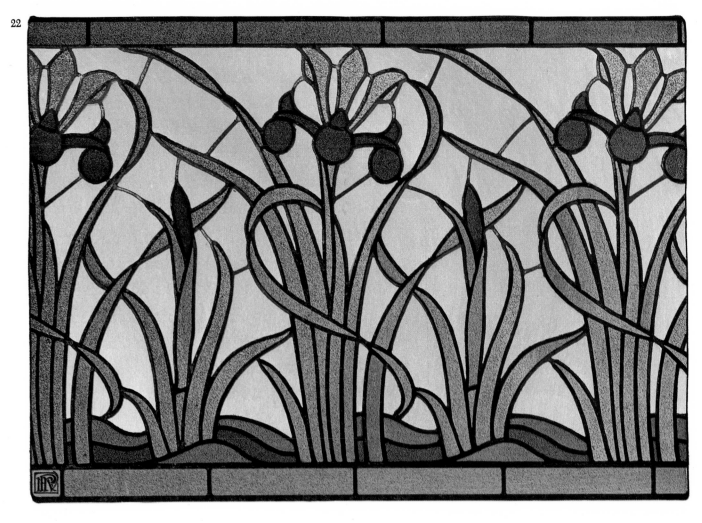

21. Cyclamen. **22.** Iris. **23.** Poppy. **24.** Lady's slipper. **25.** Bulrush.

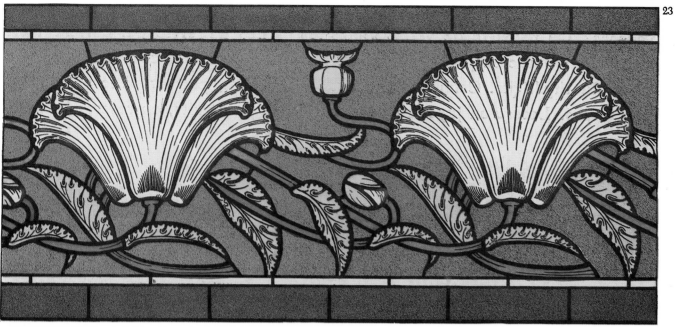

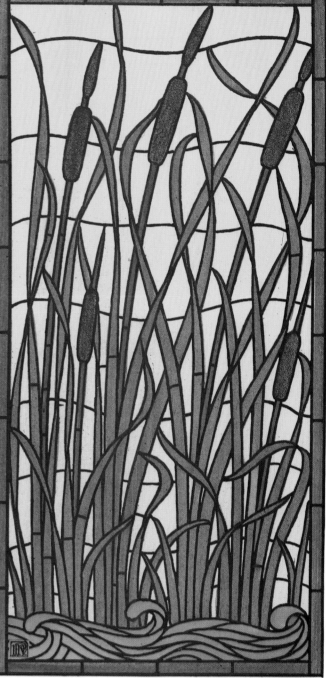

26

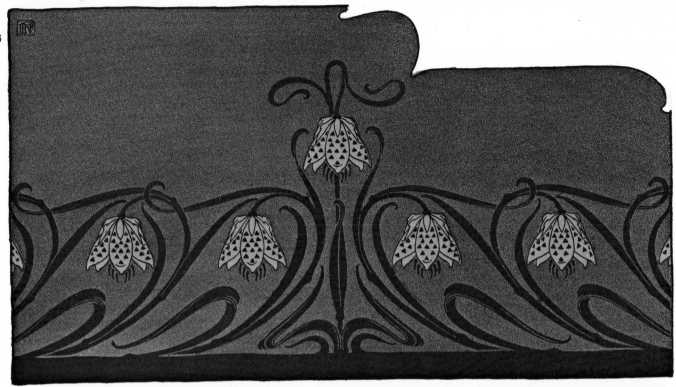

27

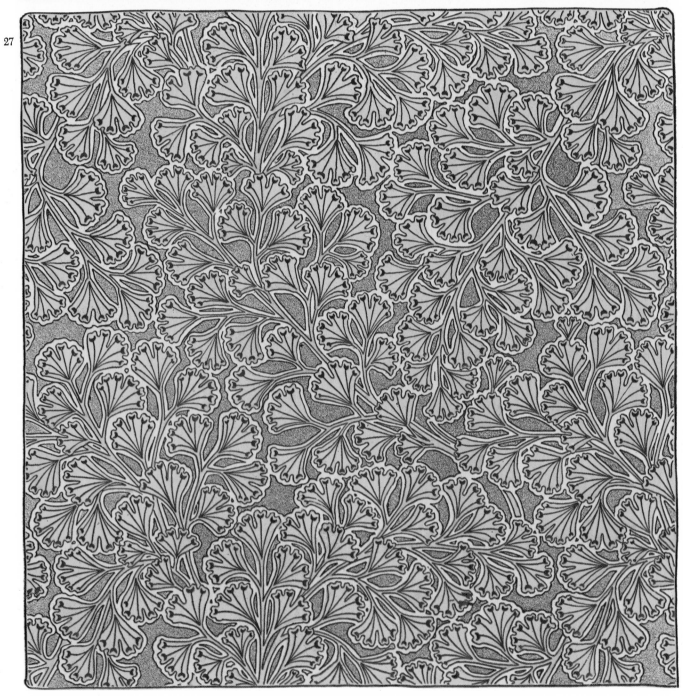

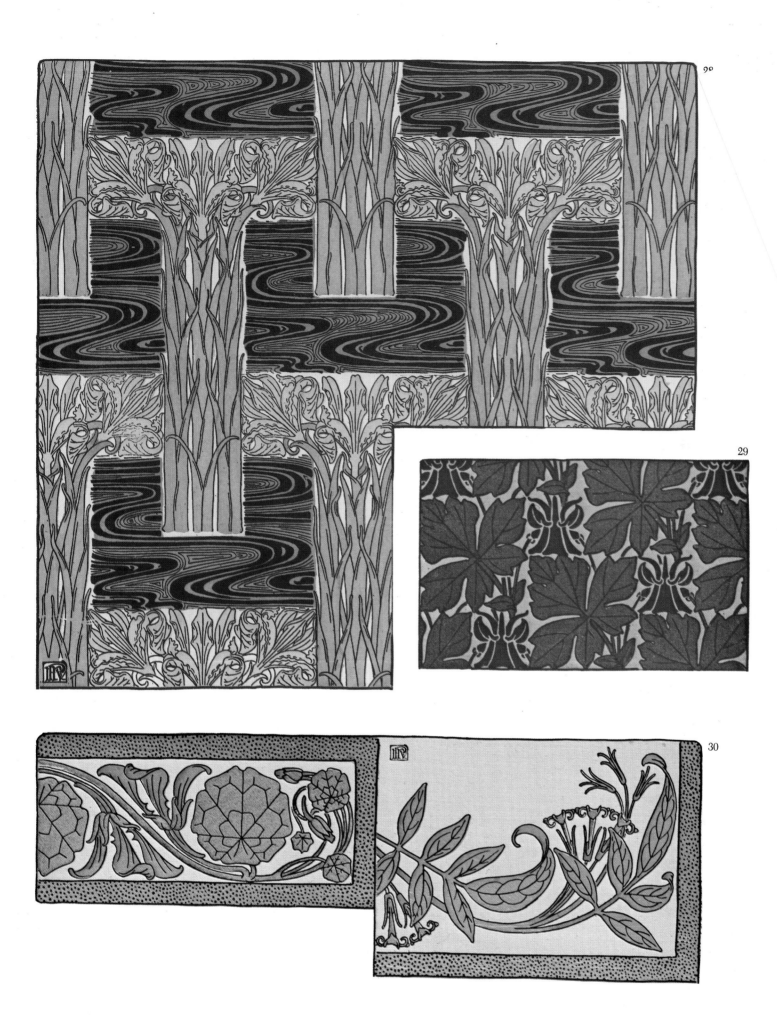

26. Fritillary. **27.** Maidenhair fern. **28.** Wild iris. **29.** Columbine. **30.** (Decorative corners.)

13

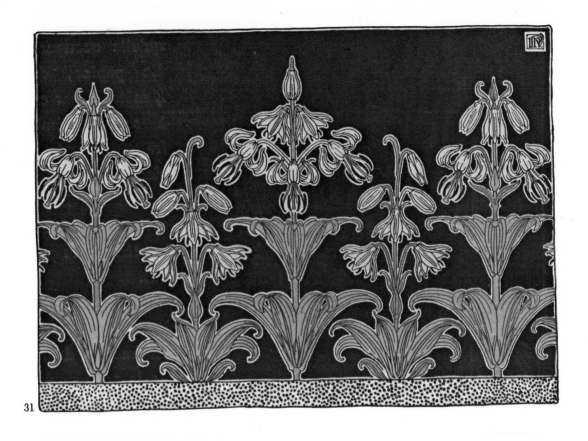

31

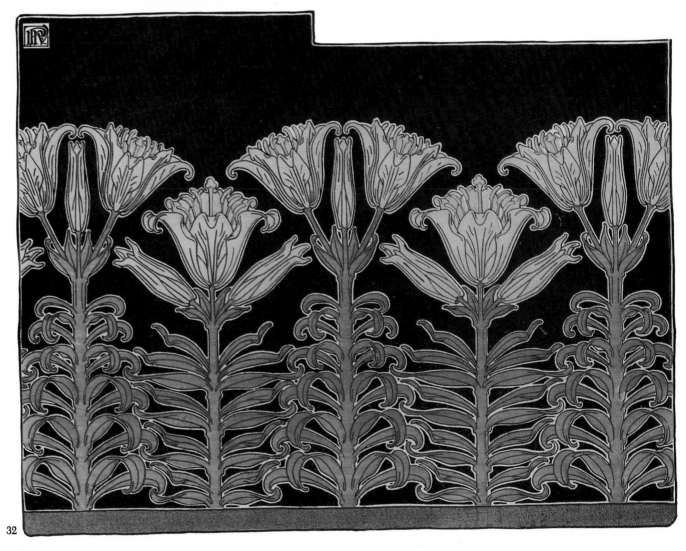

32

14 **31.** Martagon lily. **32.** Species of lily. **33.** Mushrooms. **34.** Fritillary.

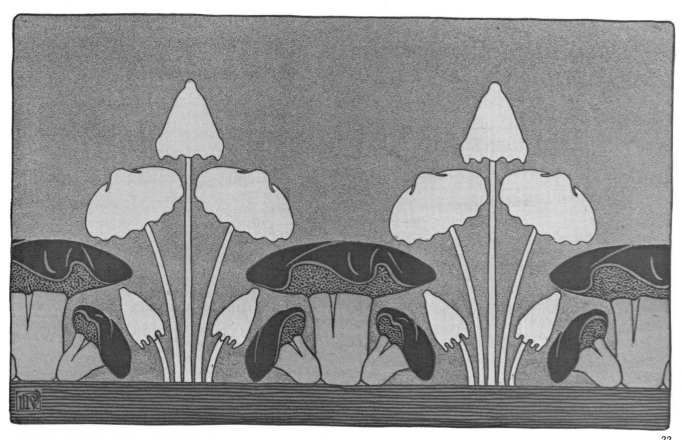

33

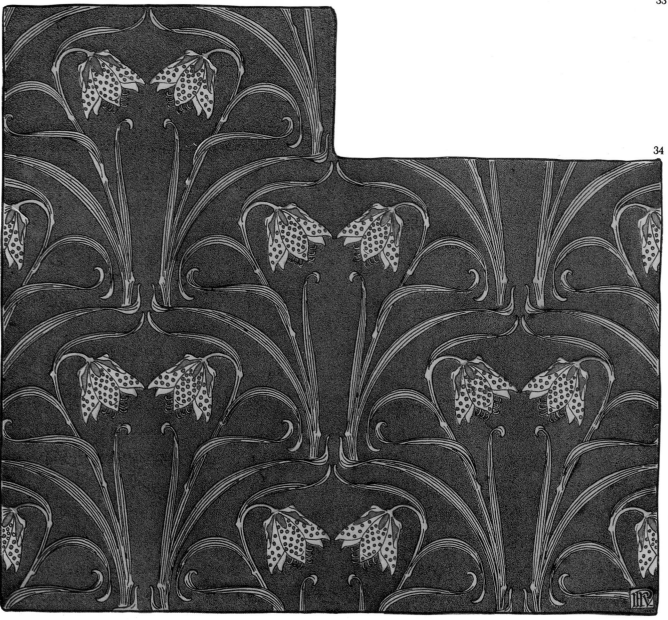

34

15

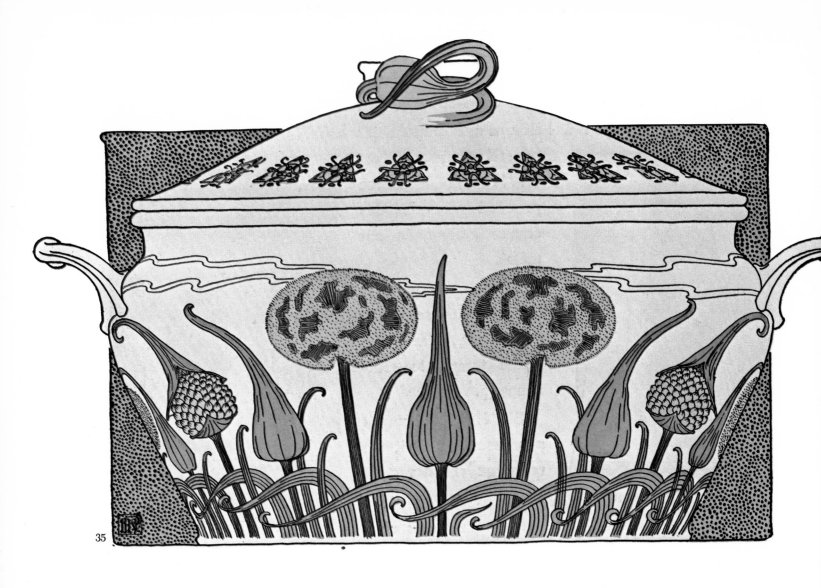

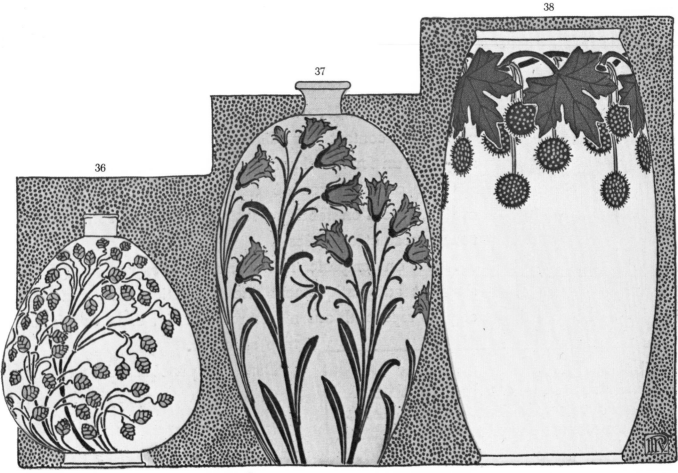

35. Leek. 36. Quaking grass. 37. Bellflower. 38. Plane tree. 39. Dandelion. 40. Horn poppy.
41. Fuchsia. 42. Lily of the valley. 43. Lady's slipper. 44. Cyclamen.

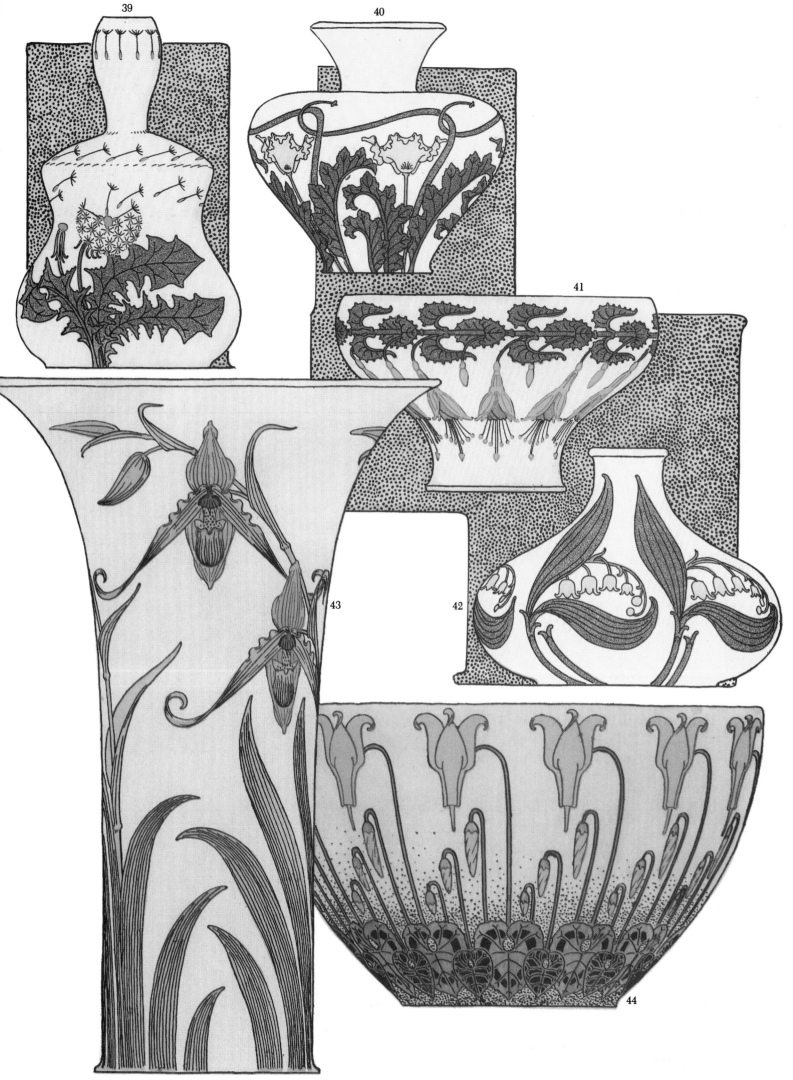

39

40

41

43

42

44

17

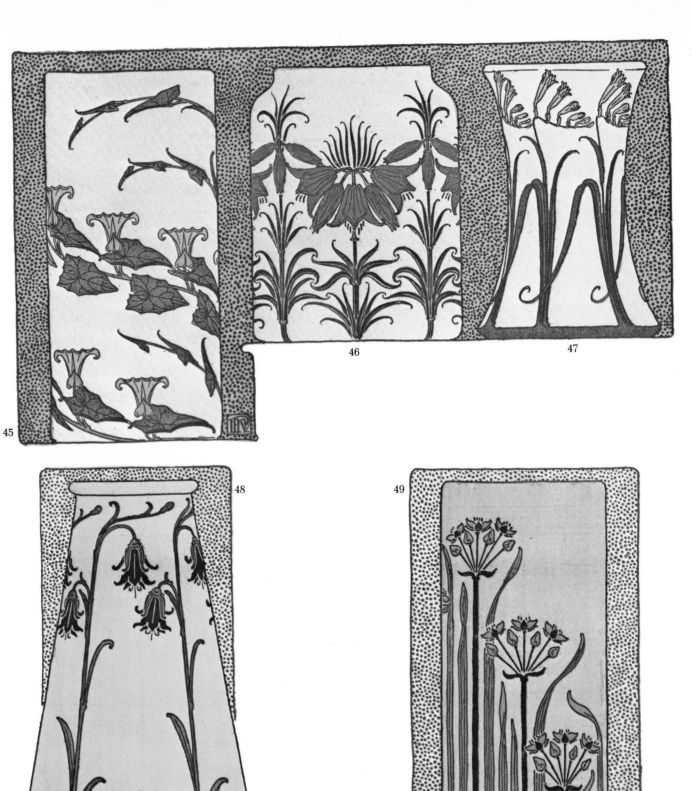

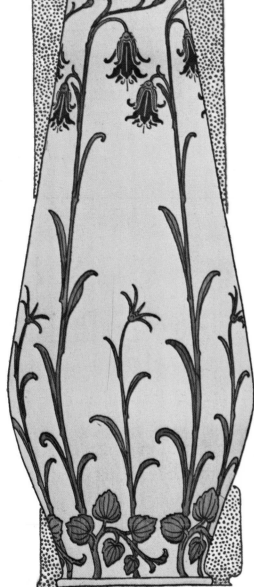

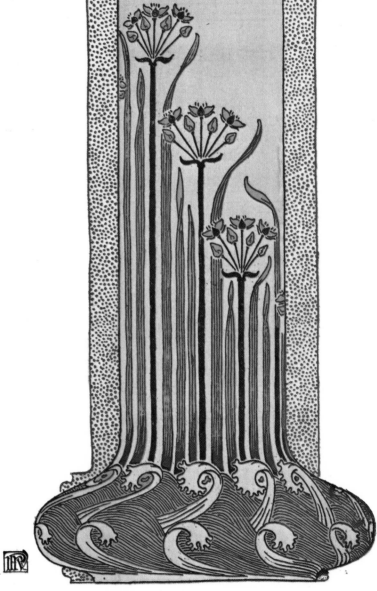

18 **45.** Bindweed. **46.** Fritillary. **47.** Freesia. **48.** Bellflower. **49.** Butomus (flowering rush).

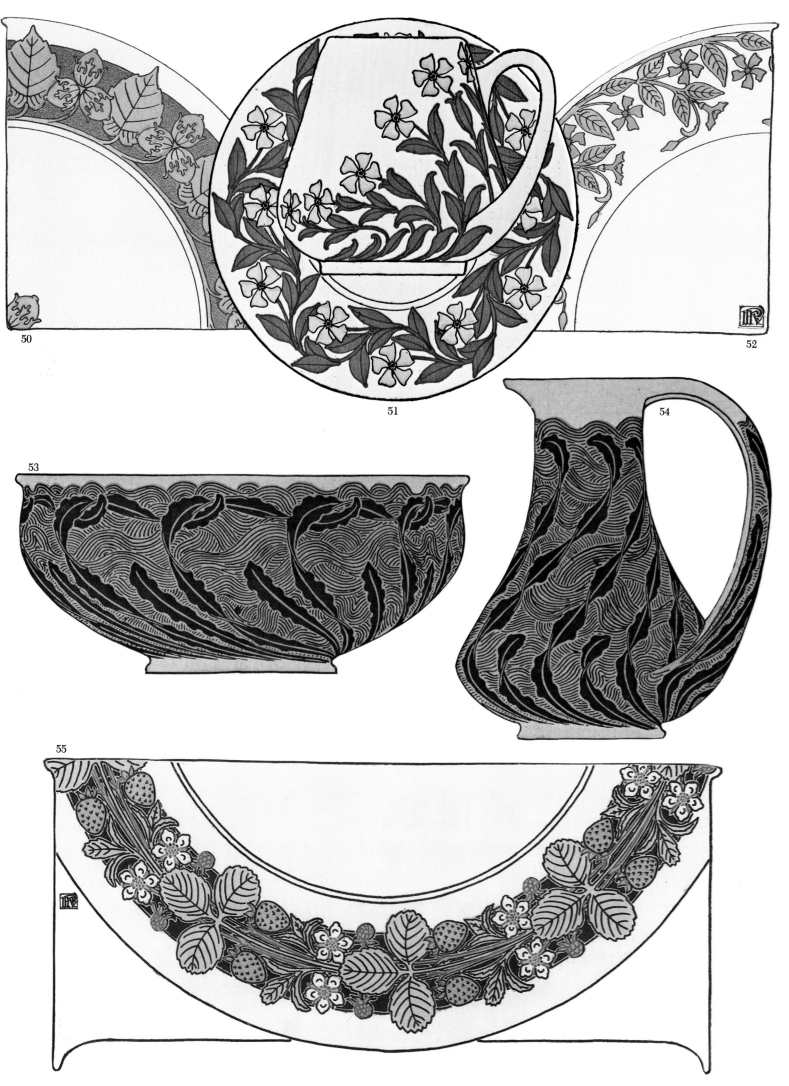

50. Hazel. **51 & 52.** Periwinkle. **53 & 54.** Green seaweed. **55.** Strawberry.

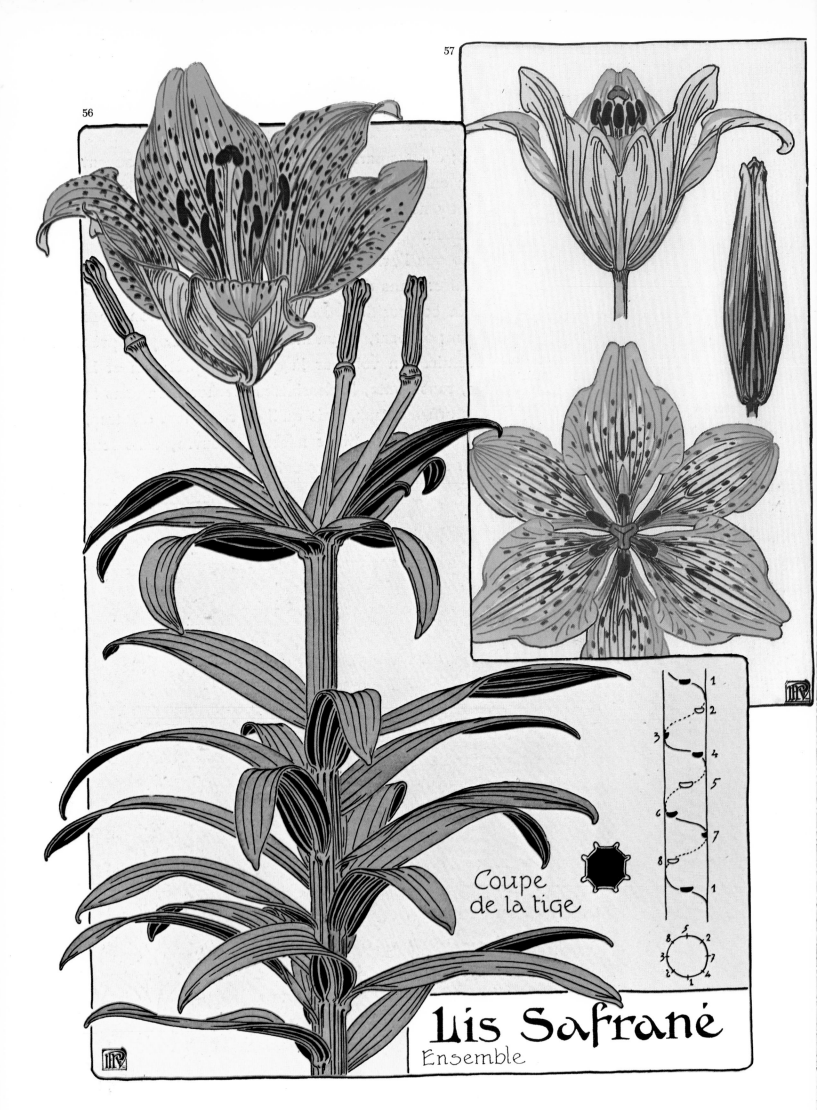

56

Coupe
de la tige

Lis Safrané
Ensemble

56 & 57. Species of lily.

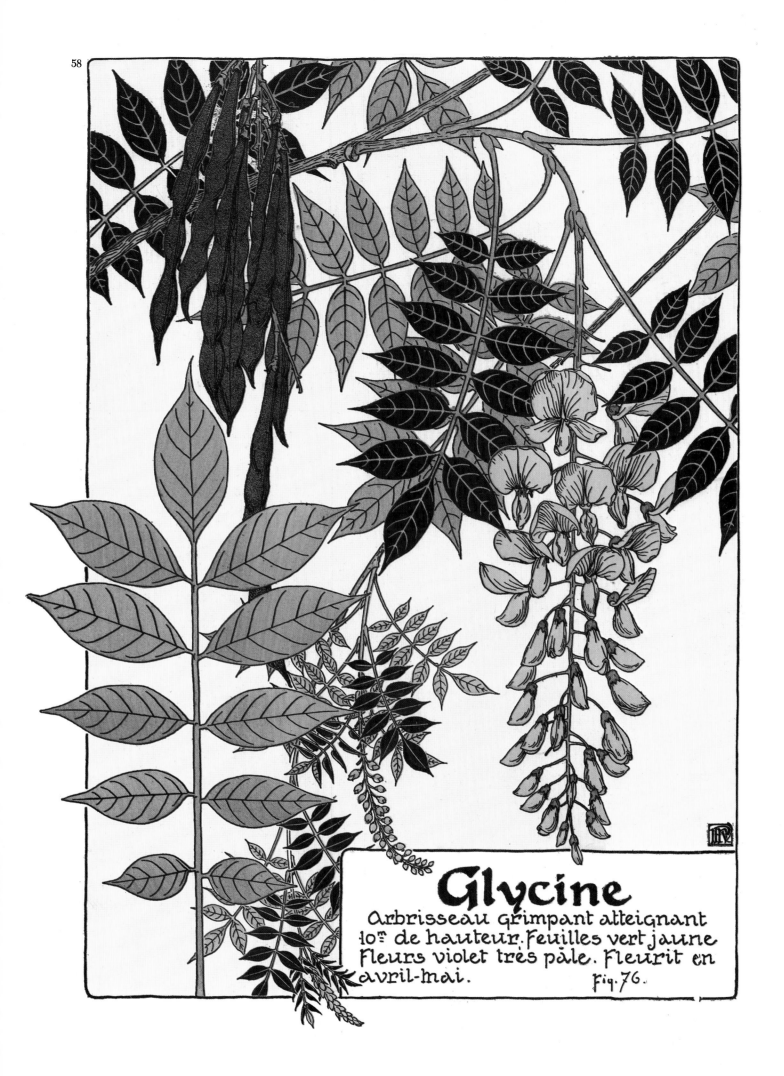

Glycine

Arbrisseau grimpant atteignant 10ᵐ de hauteur. Feuilles vert jaune. Fleurs violet très pâle. Fleurit en avril-mai.

Fig. 76.

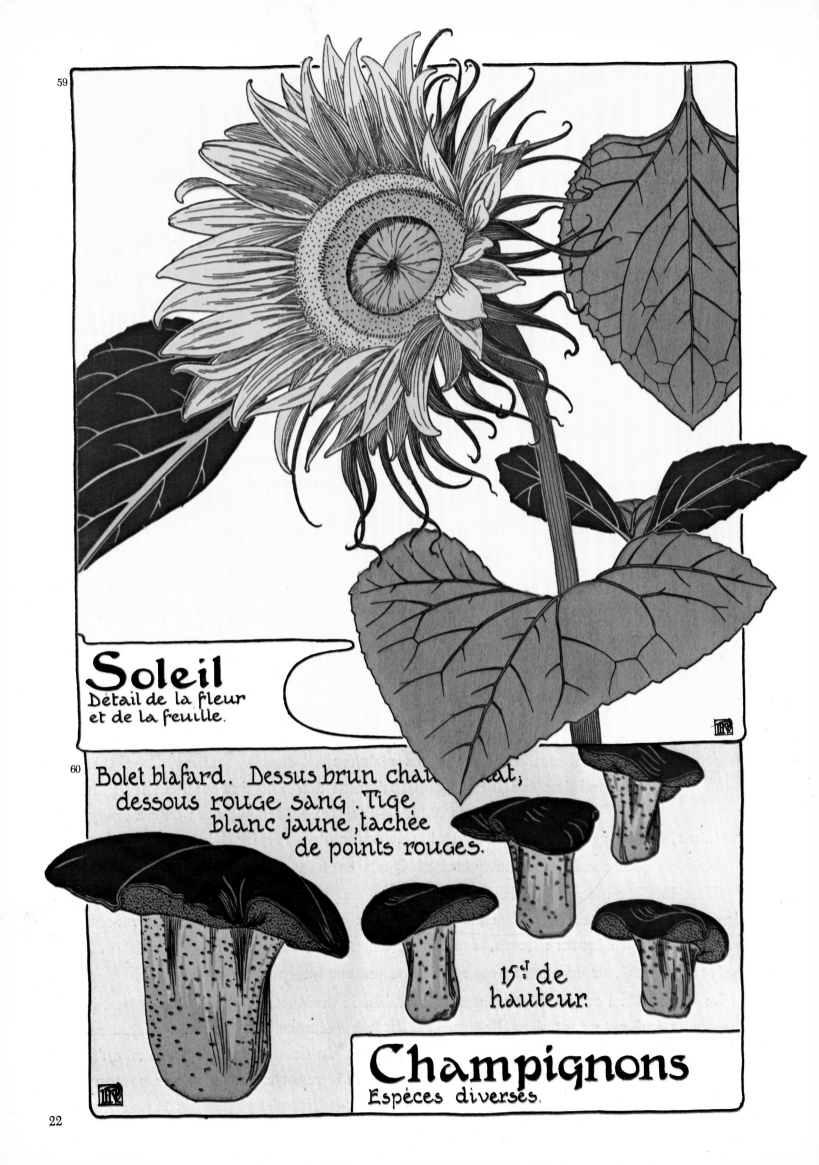

59

Soleil
Détail de la fleur
et de la feuille.

60 Bolet blafard. Dessus brun chaud éclat;
dessous rouge sang . Tige
blanc jaune ,tachée
de points rouges.

15ᵗ de
hauteur.

Champignons
Espéces diverses.

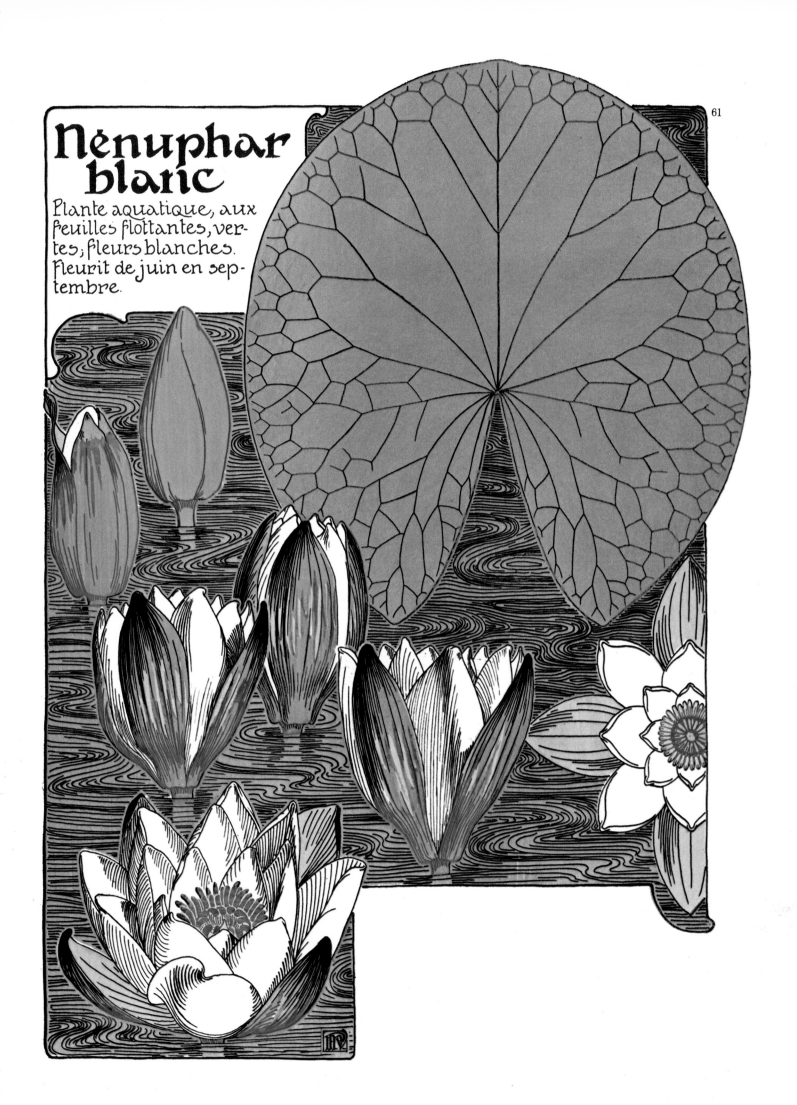

Nénuphar blanc

Plante aquatique, aux feuilles flottantes, vertes; fleurs blanches. Fleurit de juin en septembre.

61

59. Sunflower. 60. Mushroom of the genus *Boletus*. 61. White water lily.

Couronne impériale

Ensemble et detail des fleurs

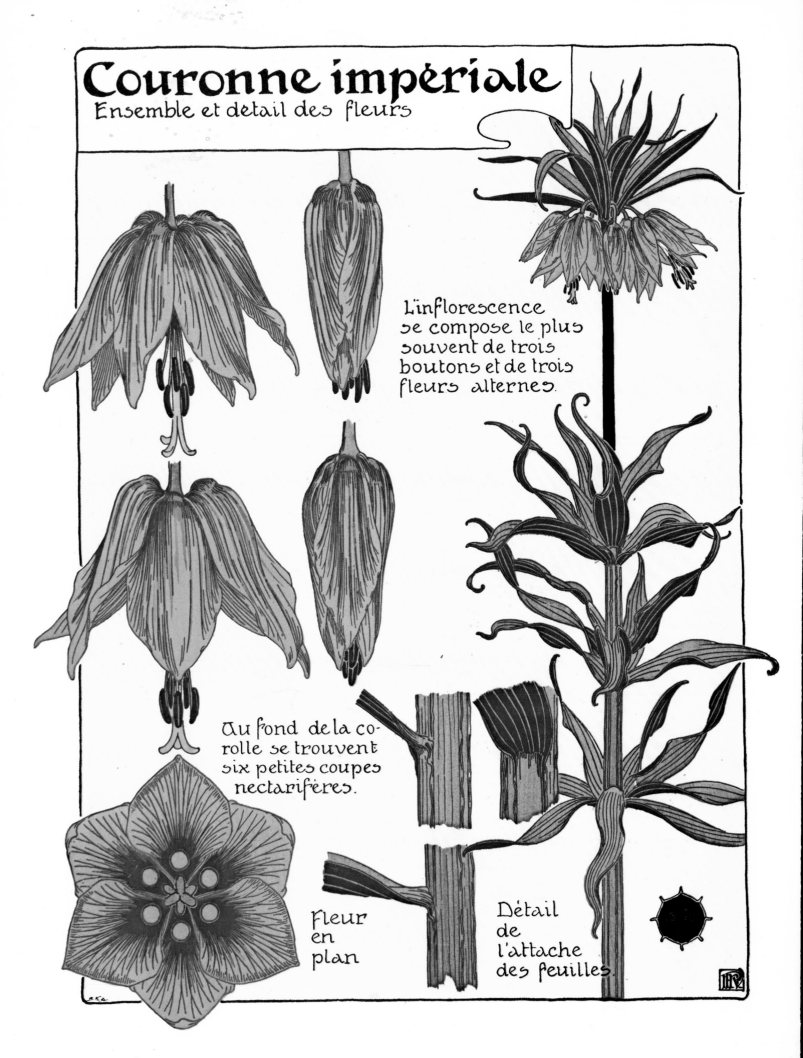

L'inflorescence se compose le plus souvent de trois boutons et de trois fleurs alternes.

Au fond de la corolle se trouvent six petites coupes nectarifères.

Fleur en plan

Détail de l'attache des feuilles.

62. Crown imperial.

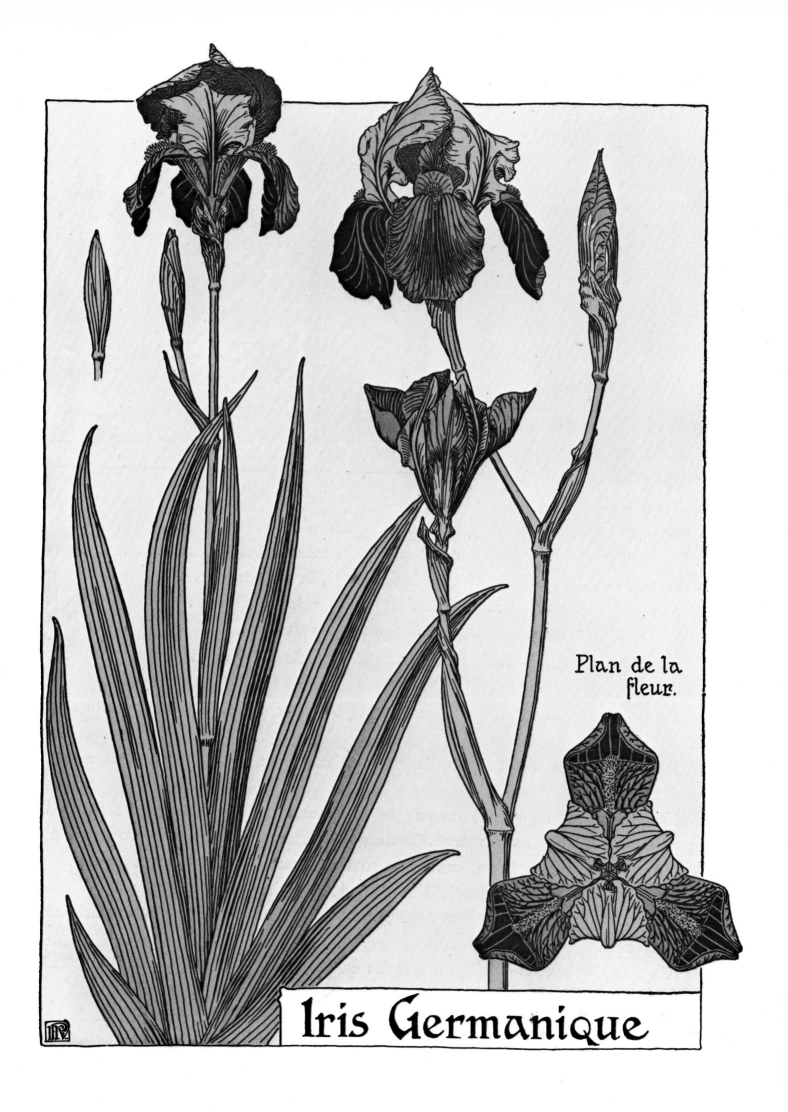

Plan de la
fleur.

Iris Germanique

63. Species of iris.

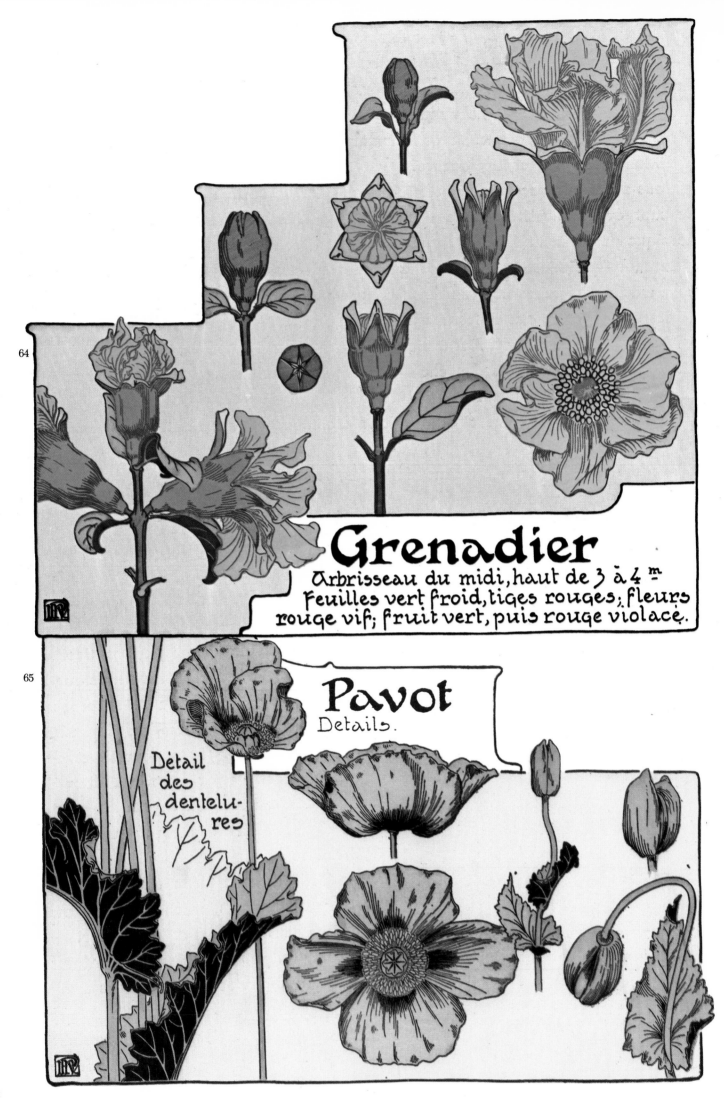

Grenadier

Arbrisseau du midi, haut de 3 à 4 ᵐ.
Feuilles vert froid, tiges rouges; fleurs
rouge vif; fruit vert, puis rouge violacé.

Pavot

Details.

Détail des dentelures

64

65

Étoffes tissées

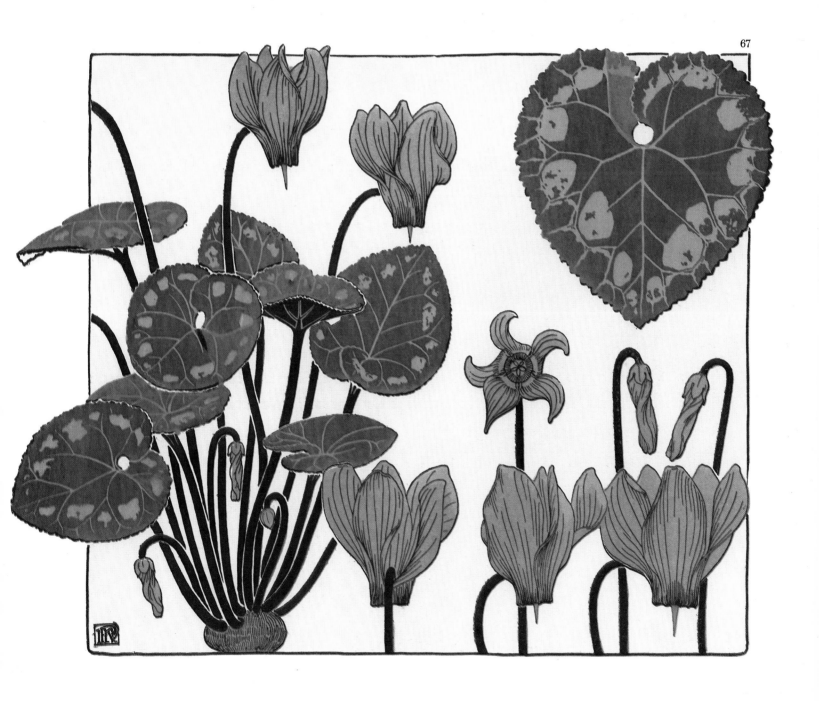

64. "Grenadier," flowering shrub of the south of France. **65.** Poppy. **66.** (Decorative heading.)
67. Cyclamen.

68

Fonds ornés et raccords

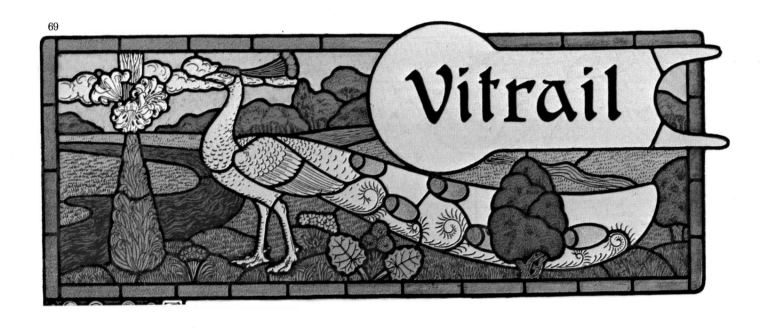

69

Vitrail

70

Papiers peints et étoffes imprimées

68–70. (Various decorative headings.)

Interprétation

Bordures

Étude de la plante

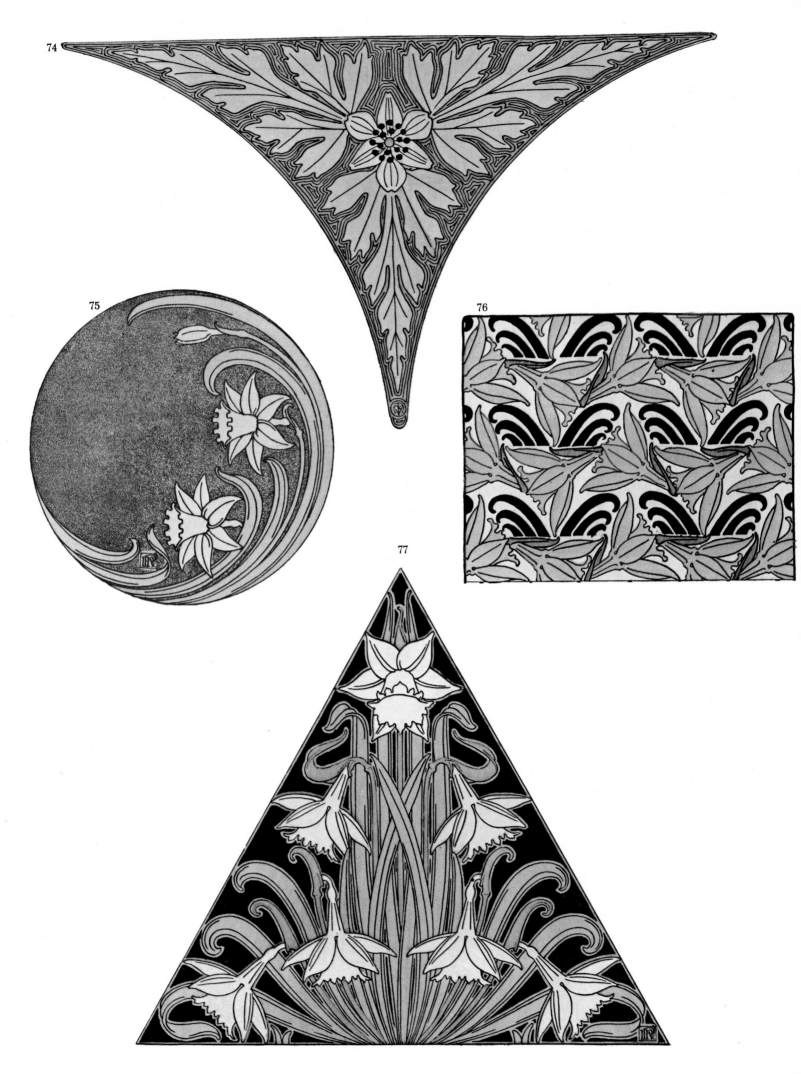

74. Wood anemone. **75–77.** *Porillon* (French name). **78.** Hazel. **79.** Sunflower. **80.** Yellow water lily.

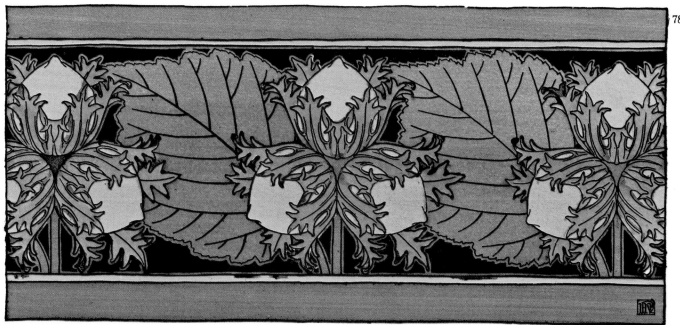

78

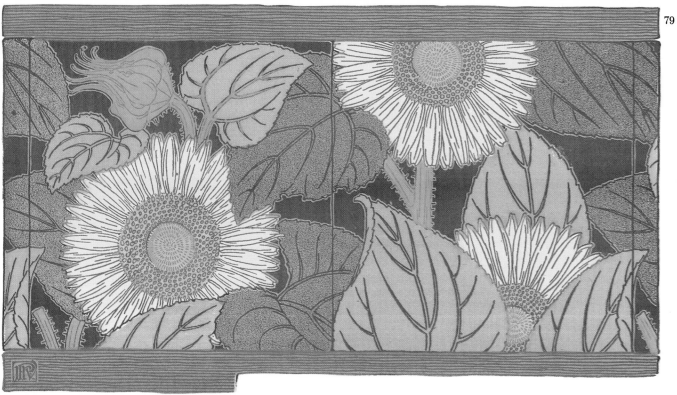

79

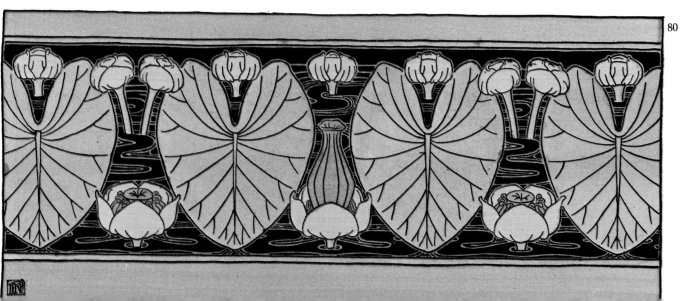

80

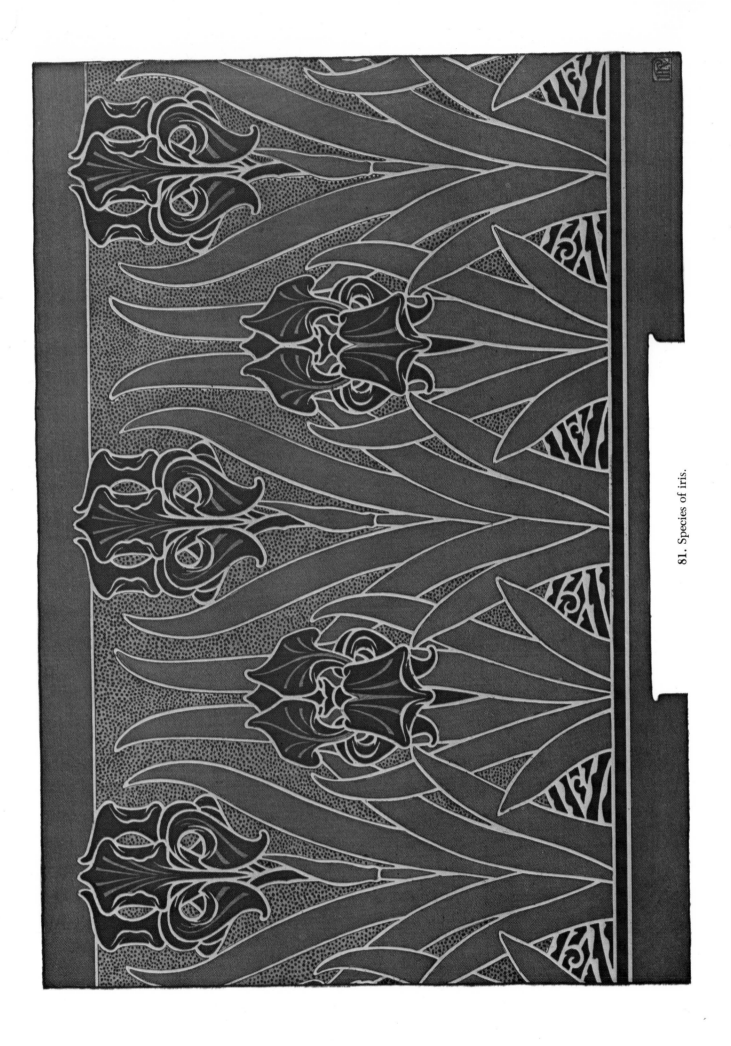

81. Species of iris.

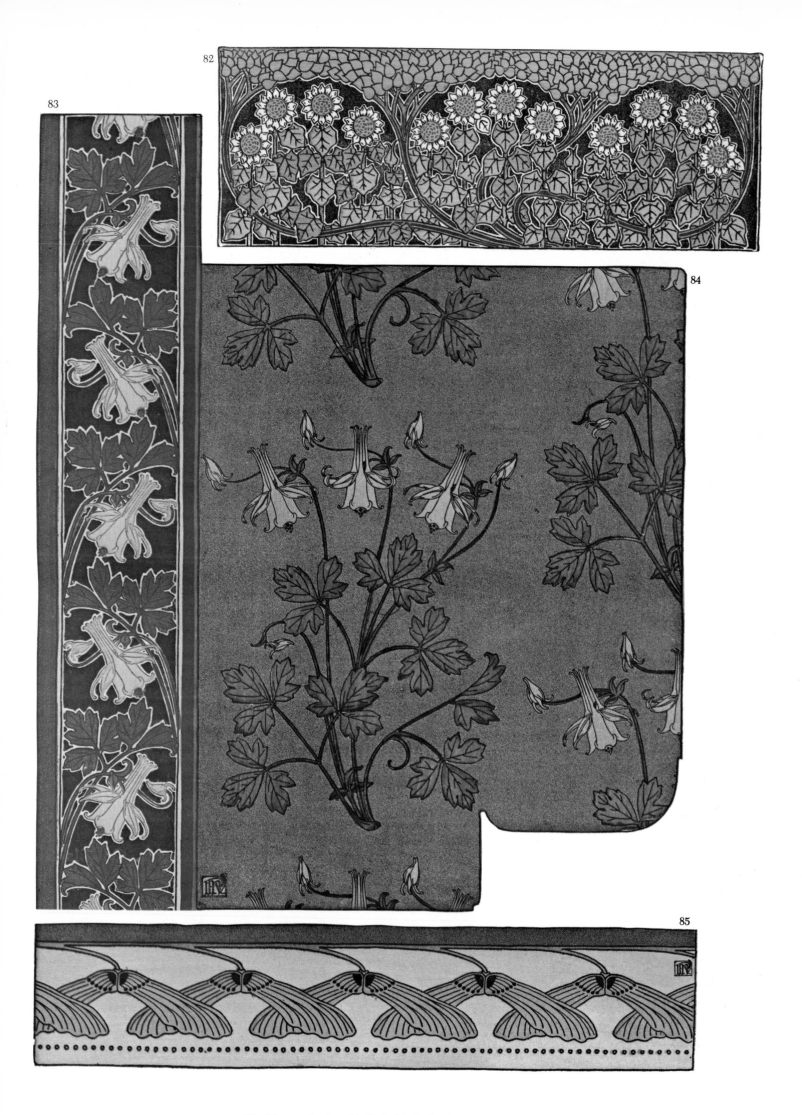

82. (Decorative band.) 83 & 84. Columbine. 85. Maple.

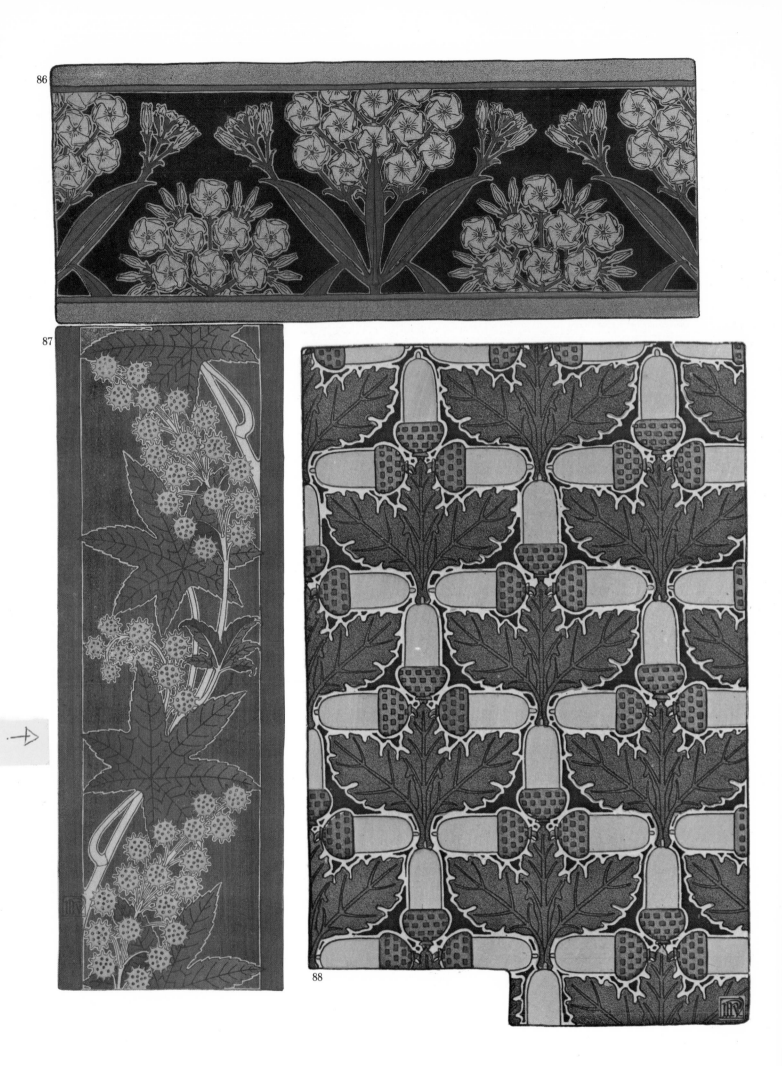

86. Oleander. 87. Castor-oil plant. 88. Oak.

89

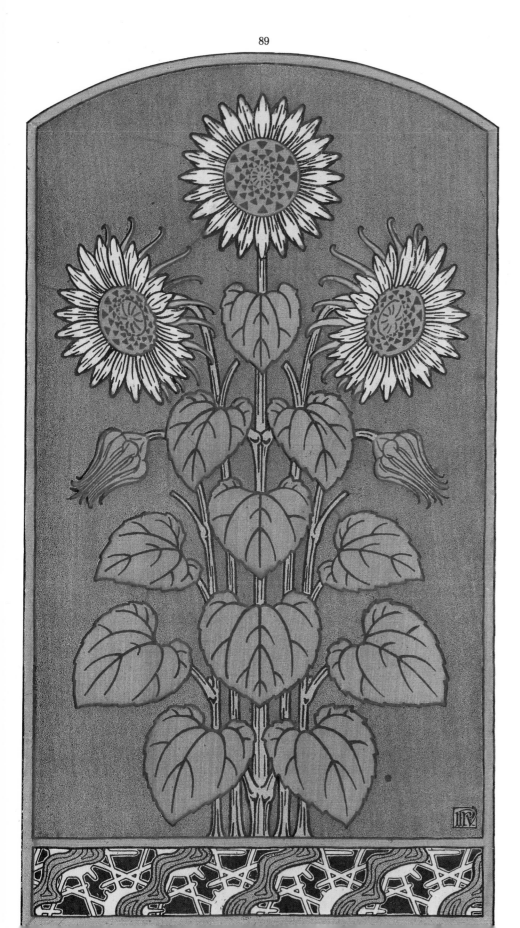

90

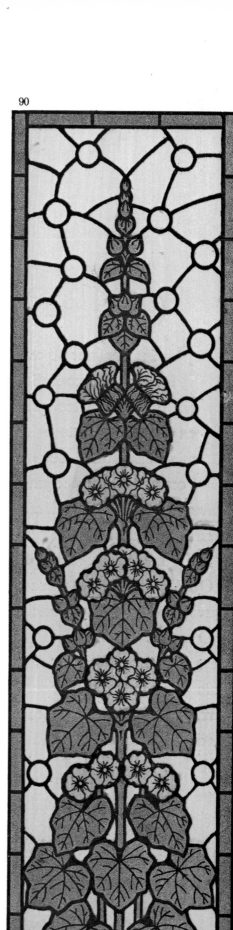

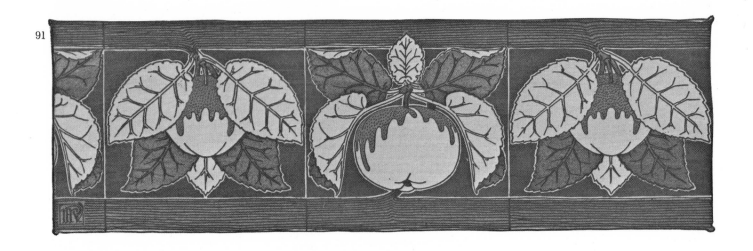

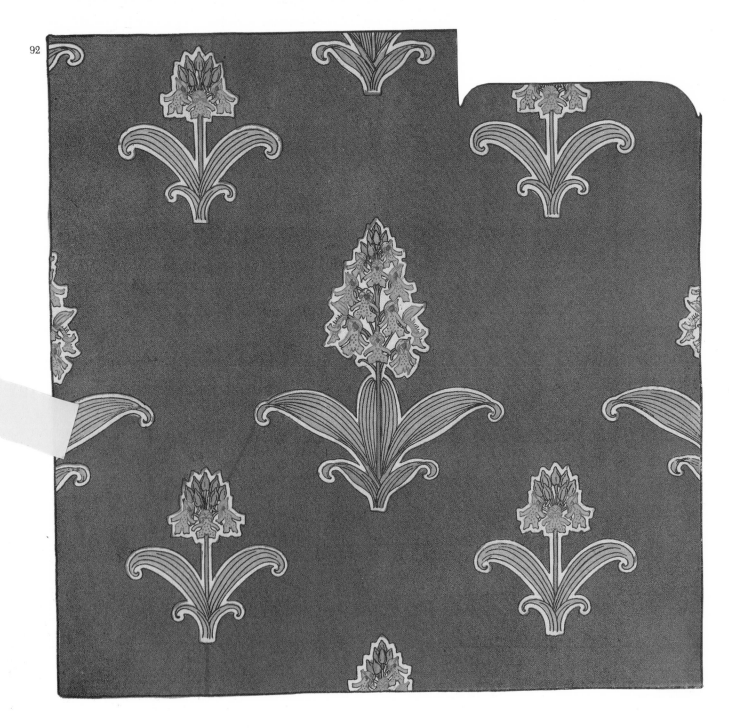

36 **91.** Apple. **92.** Wild orchid. **93.** Fuchsia. **94.** Chestnut.

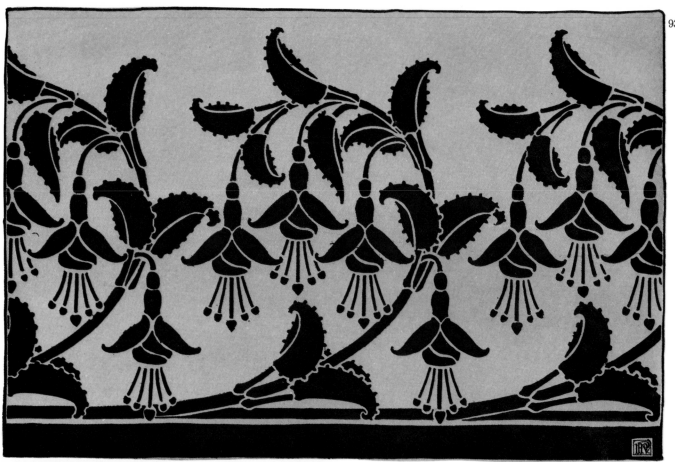

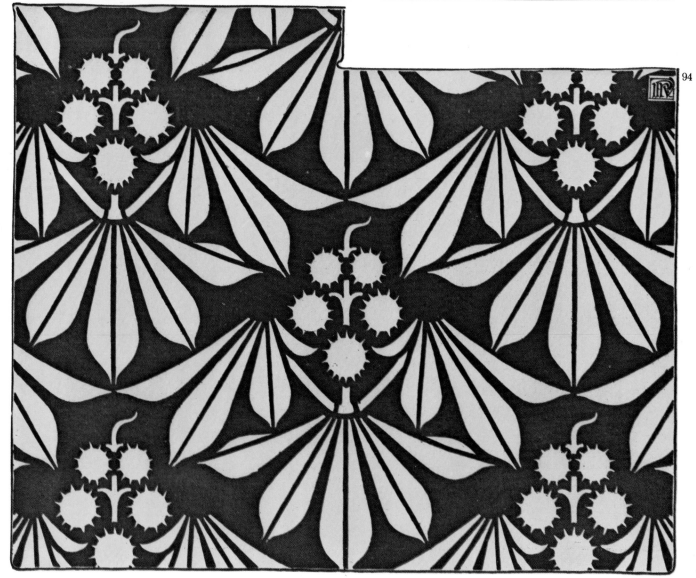

95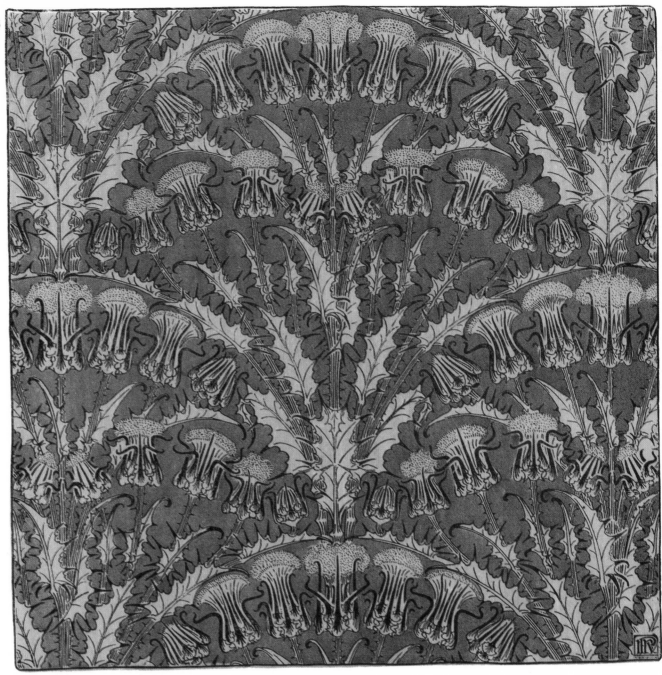

96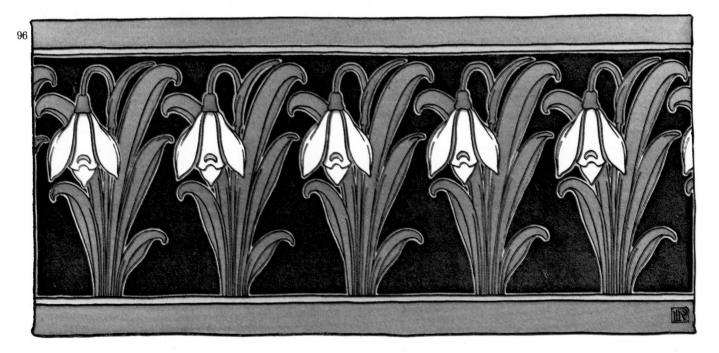

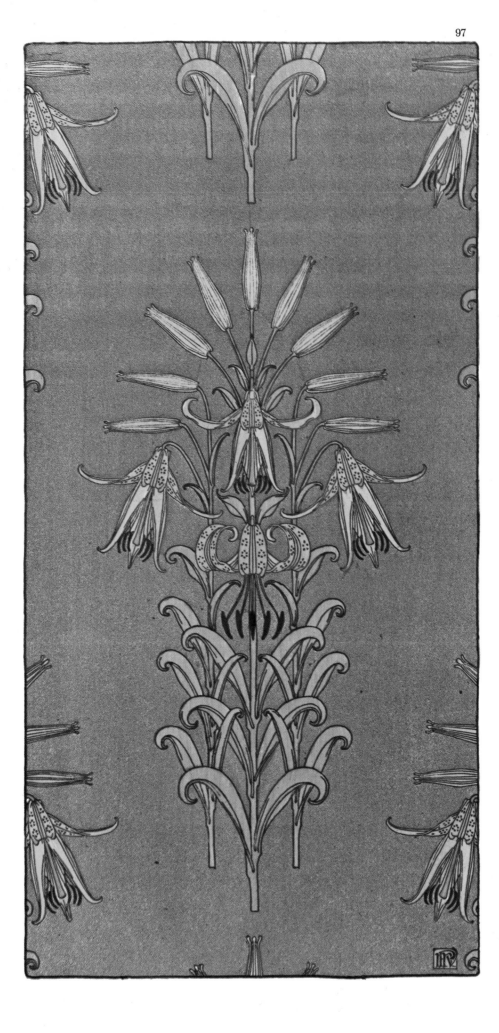

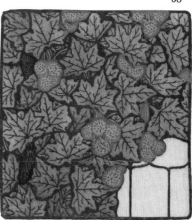

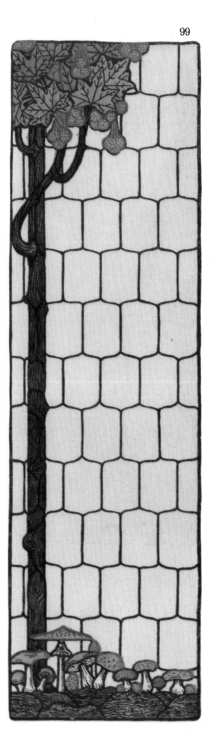

95. Milk thistle. **96.** Snowdrop. **97.** Tiger lily. **98 & 99.** Plane tree.

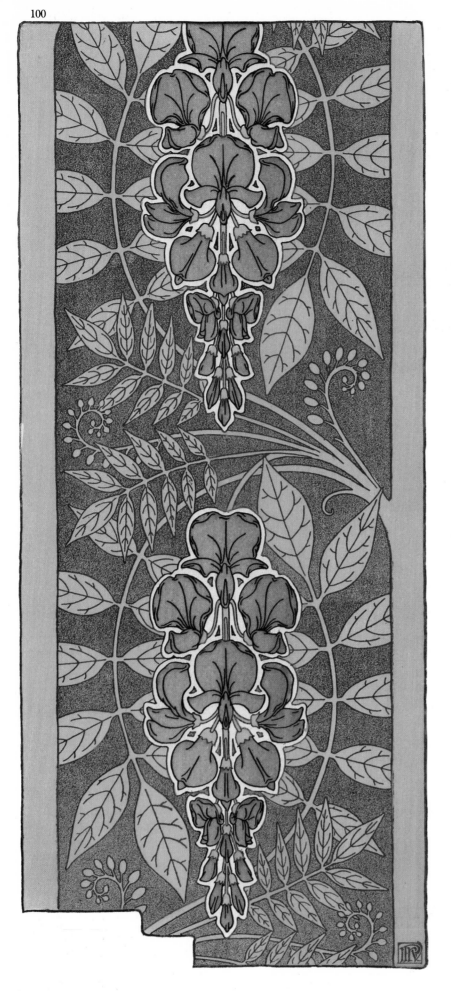

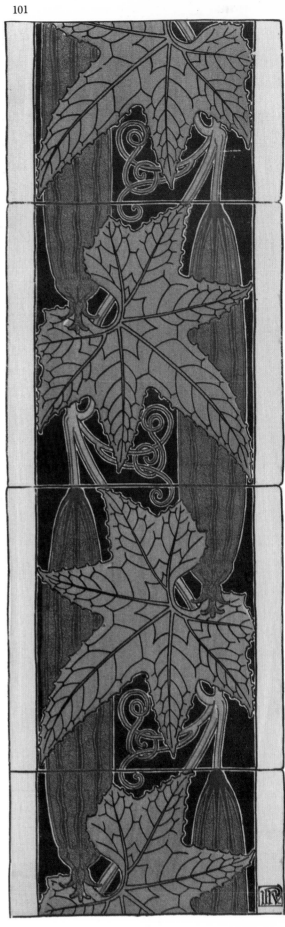

100. Wisteria. **101.** Loofah. **102.** Wood anemone. **103.** *Porillon* (French name). **104.** Gourd.

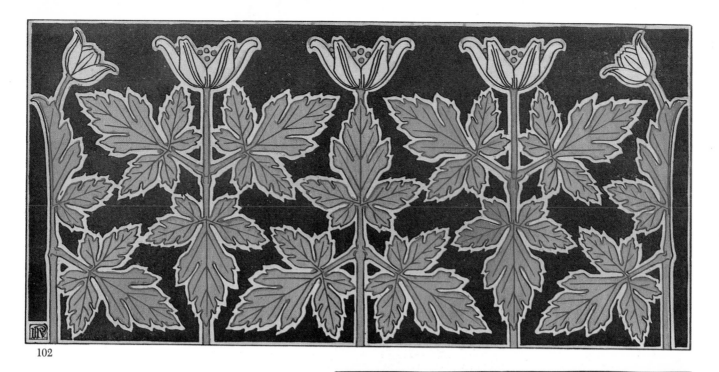

102

103

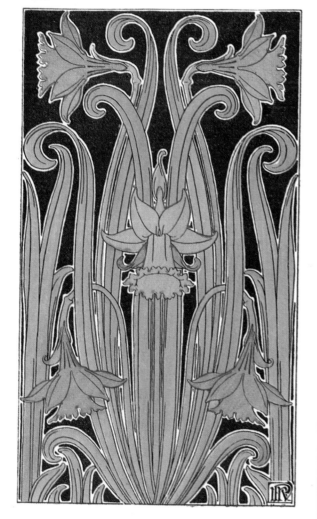

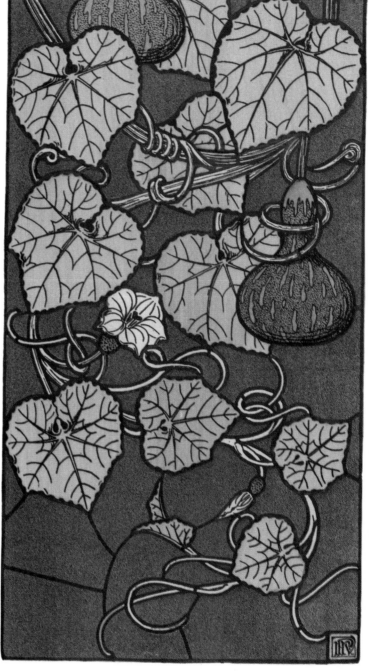

104

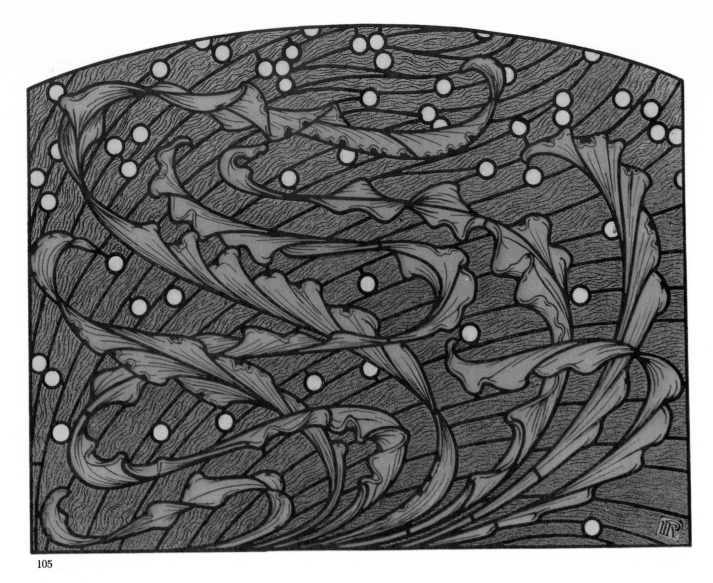

105

105. Seaweed. **106.** (Decorative heading.) **107.** Cyclamen. **108.** Nasturtium.

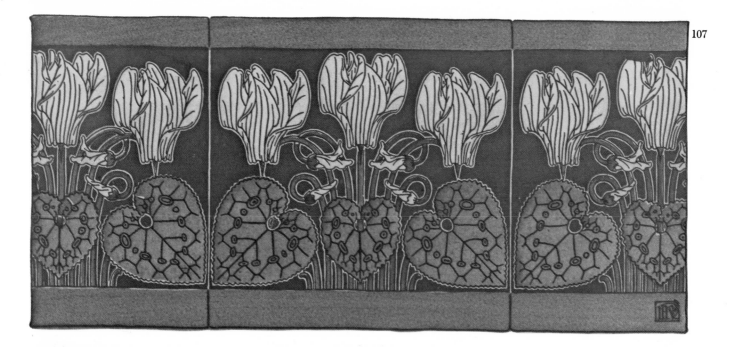

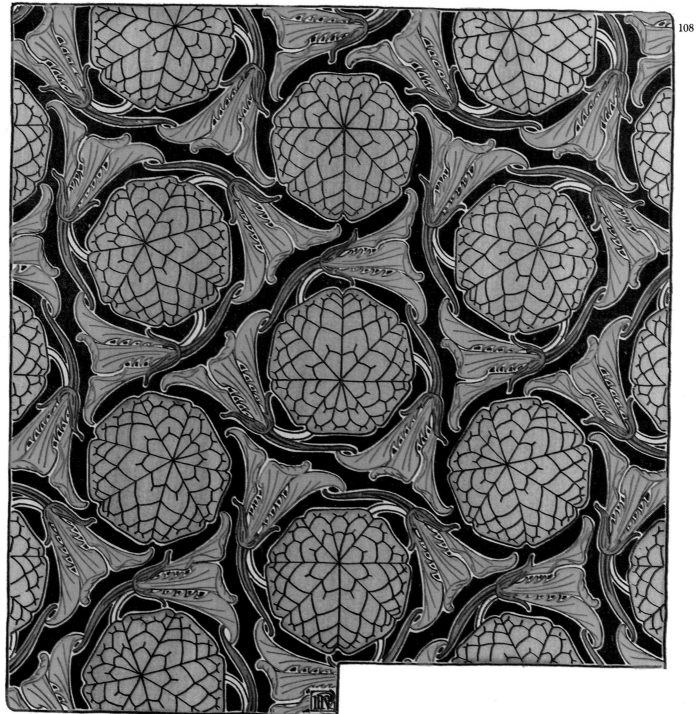

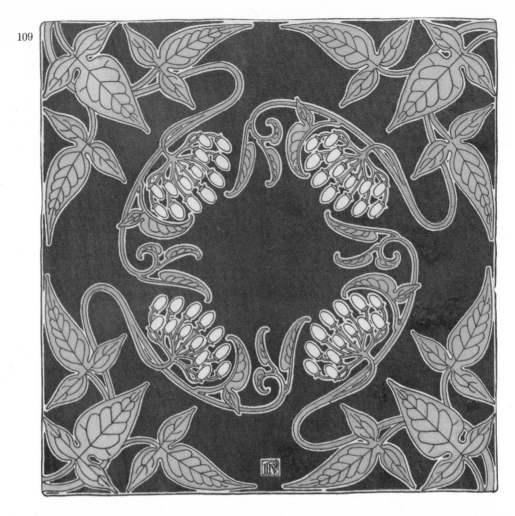

109

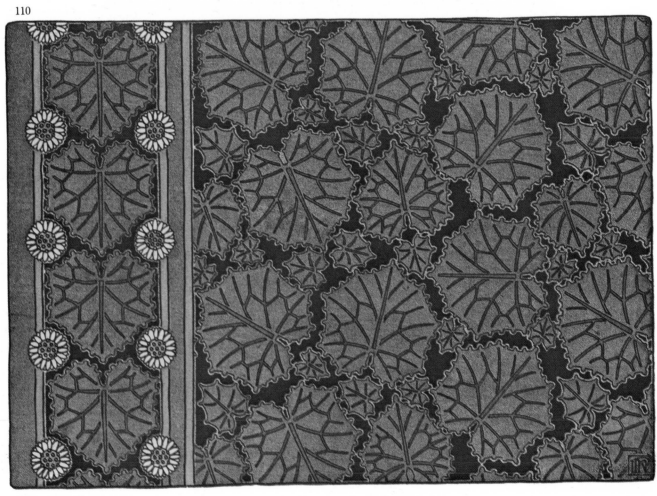

110

109. Bittersweet (woody nightshade). 110. Coltsfoot. 111. Pomegranate. 112. Poppy.

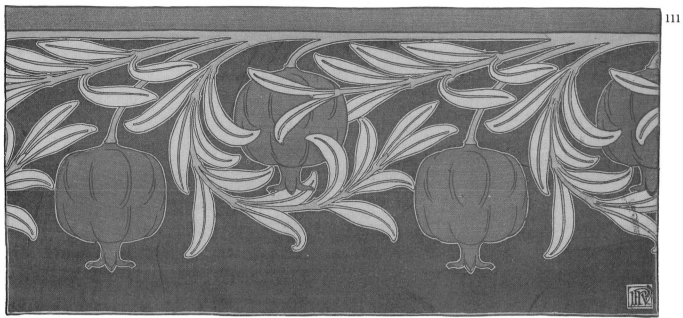

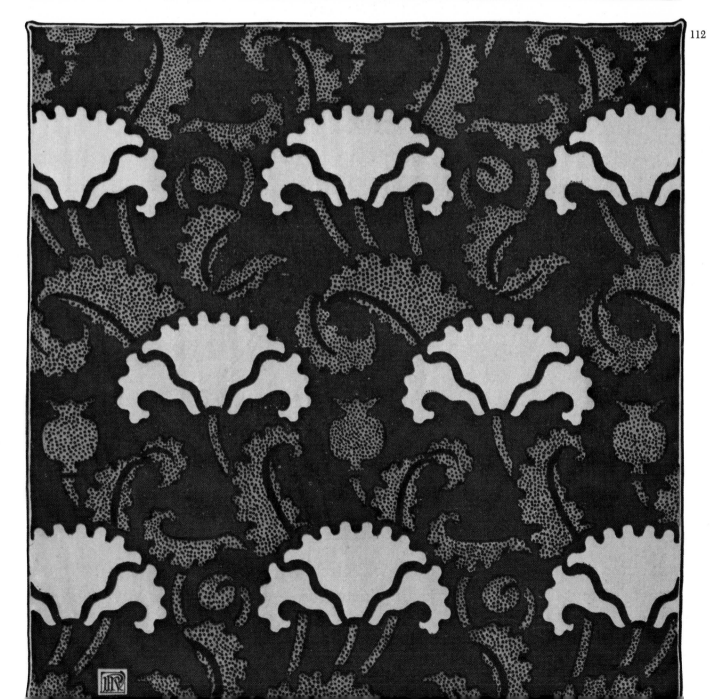

113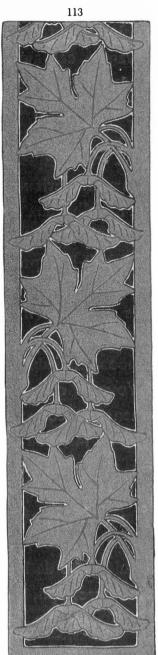

115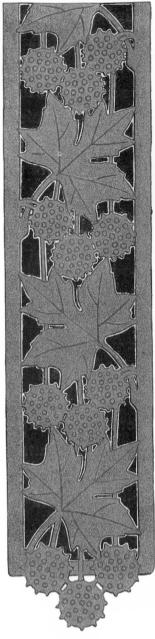

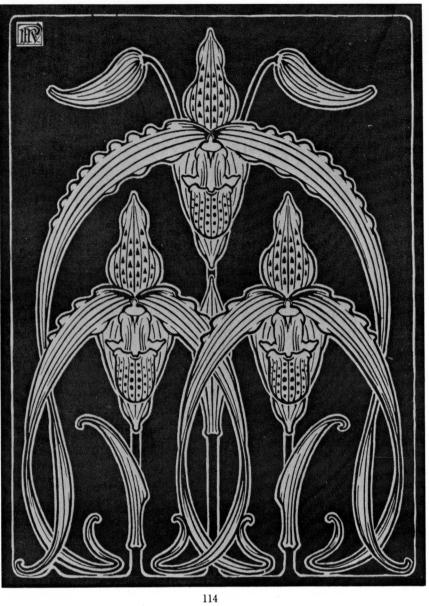

114

116

46 113. Maple. 114. Lady's slipper. 115. Plane tree. 116. Water lily and arrowhead.

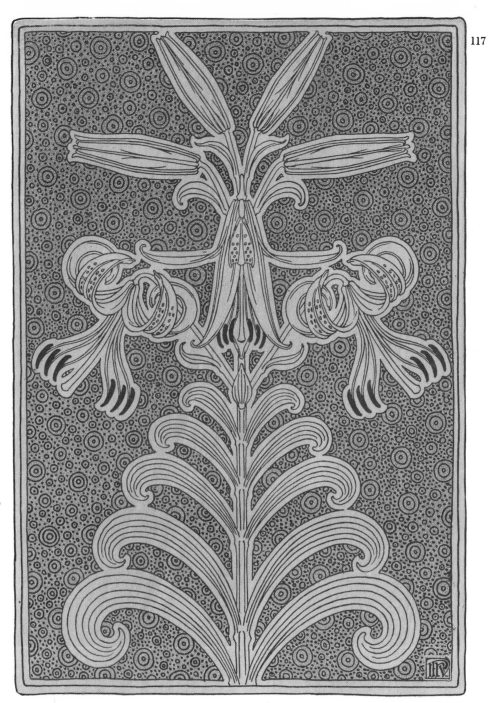

117

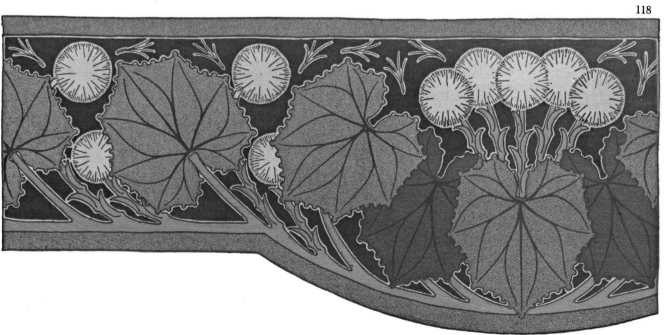

118

117. Tiger lily. 118. Coltsfoot.

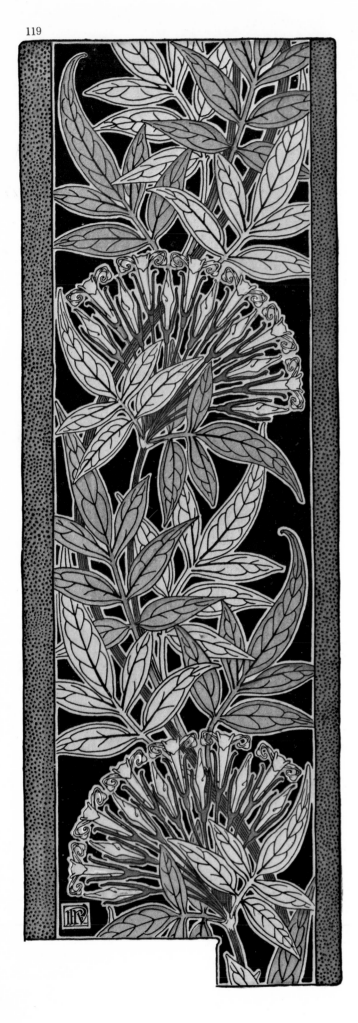

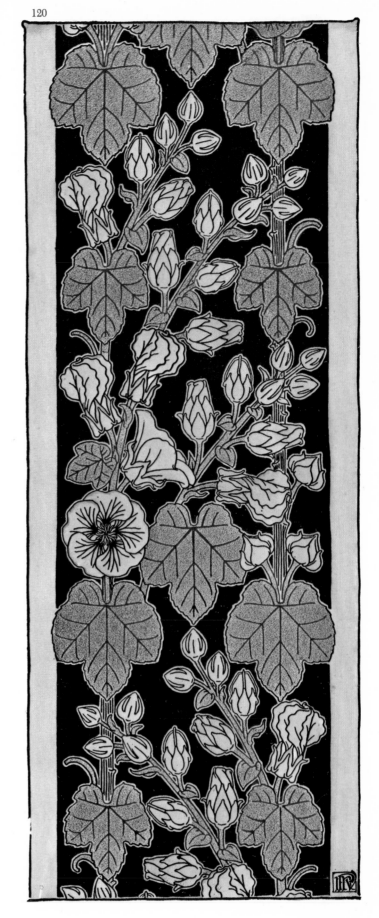

119. Jasmine. 120. Hollyhock.